Bessie Pease Gutmann ✒ Her Life and Works

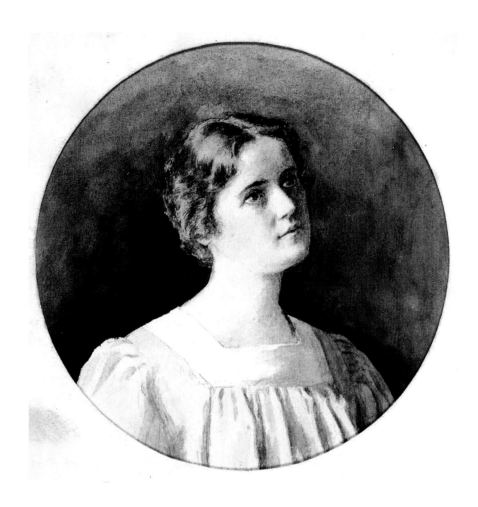

Self-portrait, Bessie Pease Gutmann, c. 1892. Written in pencil on the reverse of this study is "Watercolor from Photograph, Bessie Collins Pease, Mount Holly, N. Jersey." Handwritten in ink is "Self-portrait of my mother, age sixteen (signed) Alice Gutmann Smith. A gift to Dr. Victor Christie, April 10, 1988."

Bessie Pease Gutmann

Her Life and Works

Victor J.W. Christie, Ed.D.

Wallace-Homestead Book Company • Radnor, Pennsylvania

Cover design: Anthony Jacobson
Interior design: Arlene Putterman
Photography: Greg Heisey, C.P.P.

Manufactured in the United States of America

Library of Congress Cataloging-in-Publication Data

Christie, Victor J. W.
 Bessie Pease Gutmann: her life and works/Victor J.W. Christie.
 p. cm.
 Includes bibliographical references (p. 189) and index.
 ISBN 0-87069-561-4
 1. Gutmann, Bessie Pease. 2. Artists—United States—Biography.
I. Title.
N6537.G88C4 1990
741.6′092—dc20
 [B] 90-70544
 CIP

1 2 3 4 5 6 7 8 9 0 9 8 7 6 5 4 3 2 1 0

Published works of Bessie Pease Gutmann copyrighted by The Balliol Corporation
(Lancaster, PA 17603) are used herein by permission.

Contents

Foreword

As an illustrator and painter of babies and children, Bessie Pease Gutmann had a loyal following of admirers throughout her career. Since her death in 1960, this interest has continued through collectors of the prints, postcards, books and other paper ephemera which reproduced her work.

This interest is expanding. Many of the subjects illustrated by Mrs. Gutmann are being reissued. A Bessie Pease Gutmann Bulletin and an official Newsletter of the Gutmann Collectors Club, Inc. also attest to this loyalty. Until recently, however, Mrs. Gutmann has been relatively unknown in other art circles, obscure even as an illustrator. Although she did some advertising, book illustration, and a limited amount of magazine illustrations early in her career, she did not become well-known in those fields. Her labors were confined to the art print field for so long—in fact, confined almost exclusively to her husband's printing firm, Gutmann and Gutmann—that the larger art audience was virtually unaware of her fine artistry.

This volume offers an opportunity for her work to be viewed with some perspective of time by a larger audience. The subject of babies invites sentimentality, a somewhat dangerous pathway to follow in art, but the aesthetic quality and sincerity of her endeavors keep her efforts honest and respectable. Certainly her subject is timeless and her pictures will continue to be loved in the future as much as they have been in the past.

—Walt Reed

Acknowledgments

THIS BOOK is about the "lost" American artist, Bessie Pease Gutmann, who is "found" in this book. It is especially written for those who collect and admire Bessie Pease Gutmann art-related items, for library reference shelves, and for everyone who enjoys reading a success story.

Bessie Pease Gutmann is a name absent from most listings of American artist-illustrators. Her work is recognized throughout the world but few know its origin and the person-artist behind the brush. My initial research efforts through the normal textbook sources were fruitless and disappointing and I faltered several times in my attempts to correct this injustice. I ran ads in the popular collectibles and antiques journals and discovered, almost overnight, that literally hundreds of others felt as I did. Working now with a bearable task I was quite amazed at the number of individuals, groups, businesses, agencies, and libraries across the country who made generous contributions of time and information, and who became willing accomplices in the reconstruction of the life and works of Gutmann. This book depended upon the assistance of so many that it is only proper that their generosity and unselfishness be noted with gratitude.

If there was, in fact, a beginning, it had to be with the summer of 1983, for it was out of two unlikely events that I became convinced that Gutmann was an artist worthy of research. The first of such events took place on the "Blue Goose," an ocean-going sailing craft owned and operated by Lucille and Bill Horrocks. On July 11 Betty (my partner and wife) and I accepted an invitation to meet a member of the Gutmann family. So it happened that, in the middle of the Toms River (Barnaget Bay), New Jersey, we chatted with the delightful daughter of Bessie Pease Gutmann, Lucille, and her husband, Bill. Celie, as she is called by her family, spoke lovingly of her mother and father and showed us family photos which included original artwork. I knew then that I'd write a book about this artist. It proved to be a charming and wonderful day. We enjoyed the hospitality of the company and quickly became friends.

The second event of that summer found us braving the heat of August on a journey to West Islip, New York, to meet with six other collectors that we had met at shows. We jokingly formed the one-meeting-only "Eastcoast

Bessie Pease Gutmann Collectors Group" and exchanged information about our favorite artist. The motivation to write this book was a natural by-product of the enthusiasm generated at the meeting. The participants were the primary instigators and I am deeply grateful for their friendship and words of encouragement. Eleanor "Elie" and Bill Popelka and Julie and Tommy DeLuca were catalysts for the manuscript preparation. But, most of all, I am immensely indebted to Sue and Warren Wissemann. Warren's enthusiasm matched mine, his orderly mind organized an untidy manuscript, he shared the disappointments and offered succor, initiated many primary research efforts, and, throughout the writing of drafts, served as a critical reader and made innumerable valuable suggestions. It was a fortunate day when we met this gang.

I owe much to the lovely family of Bessie Pease Gutmann. They opened their doors, hearts, and treasured memories to me. Their designation of this writer as the official biographer of their mother was a cherished compliment. The three children, Alice, Lucille, and John, their spouses and immediate families, gave me the needed encouragement and confidence to continue during the early dark days. The opportunity to view sketch books, portfolios, and other memorabilia of their mother, was an exhilarating experience that I am happy to share with you. Betty and I enjoyed our many visits over the years with Alice and her writer-husband, Bob; Celie and Bill; and John and his wife Annabelle, who has been such a stalwart person. We began as strangers but soon became warm friends. Sadly, neither John Collins Gutmann, Sr., my confidant and true friend who met a tragic death in his home in 1987 at the hands of an intruder, nor Lucille Gutmann Horrocks who died within the past year are present to bear witness to this book. The efforts were mine but the book is theirs.

It is an impossible task to express gratitude to so many sources. However, the Gutmann aficionados are deserving of special mention. In nine years of intensive research I corresponded with over three-hundred fellow collectors, visited twenty-eight states, went to literally hundreds of meetings, had a staggering number of phone conversations, and traveled enough miles to encircle the globe thrice. The result was the formation of a nationwide network of collector friends. Volunteer researchers emerged and gave freely of their time and aided in many discoveries, offered advice, allowed me to leaf through their collections and in some instances to photograph subjects. They sent hundreds of snapshots and assisted in an untold number of ways so that the following pages could be filled with information and illustrations that all readers could enjoy. Those that stand out and the states they represented are: Joan and Bill Strawhacker (PA), Pam and Jim Dickens (TX), Nancy Carr (PA), Suzanne Branard (NJ), Connie Eckert (OH), Cheryl Flynn (CT), Marle Vane (CA), Nancy Moran (CT), Susan Watt (MN), Helen Kibby (IA), Dorothy Turini (NH), Linda Arotin (OH), Janice Wozniak (IL), Kathy and Louise Wood (NJ), Kristi and Walter "Cam" Hanna (WA), Susan L. Ahrens (NJ), Suzanne Hunter (OH), Joanne Pickering (CA), Sophie and John Szot (NJ), Nellie Vullings (PA), Michele Jones (WA), Mary and Joe Connors (AK), Arleen and Joseph Catone (PA), Susan Bartlett (MD), Sheila Smith (NV), Pauline Harry (FL), Doris Crosby (NJ), Fran and George Sherman (CA), Sharon and Jim

Eckert (IL), Bev and Joe Weaver (CA), Pat and Jerry Marino (NY), and Bille Meseke (MD).

A deep sense of gratitude is extended to Marvin Mitchell, Vice-President of The Balliol Corporation (the licensor of all Bessie Pease Gutmann artwork) and the guiding hand of the national Gutmann Collectors Club, for his encouragement and belief that this book needed to be written. It was his business acumen that paved the way for the publishing of this book. It was also with his permission that the majority of the artwork in this book is reproduced.

Col. Frederic A. Frech (Ret.), whose mother was the daughter of Bessie Pease Gutmann's sister Mary, willingly shared his genealogical research of the Mayflower descendants of the Pease family. I am indebted to him for his recollections and his permission to use some of the original artwork found in this book.

Reproductions of original artwork are the very heart of this book and they serve to verify that the artist was as versatile in media use as she was in subject matter. In addition to those pieces that came from the children of Bessie Pease Gutmann there were several members of the immediate family that should be cited for their contributions. Carol Gutmann Brown, daughter of John and Annabelle Gutmann, is warmly thanked for her services as a reader, consultant, and for the use of certain original art pieces; John Collins Gutmann, Jr. and his wife Jennifer for their loan of several items important to the book and for their kind words of encouragement; Betsie Hackland Walsh, daughter of Alice Gutmann Smith, for the use of original artwork; and Theodore Lehmann II for sharing with us the research he was conducting on his grandfather, artist Bernhard Gutmann. Friends of former neighbors of the artist also made significant contributions to the early chapters of the book: Carolyn Alley Sisto, Catherine B. Hoffman, Rose Immergut, and Muriel Bauzenberger and her mother, Mabel R. Burt.

Four institutions must be singled out for special recognition for their unstinting cooperation and the willingness to provide meaningful information rather than cursory data. Robert Blackwell, principal librarian, and William J. Dane, supervising librarian, Art and Music Department of the Newark (NJ) Public Library were the first to furnish me with information that led me to many substantial research paths. Debbie Alterman, library director, and her successor, Paula Feid, library director of the Moore College of Art (formerly the Philadelphia School of Design for Women) provided me with considerable information concerning the early days of the school and an insight into the changing philosophy which brought about significant changes in the art instruction of women at the turn of the century. Lawrence Taylor, publications director for The Art Students League of New York, graciously shared his knowledge and expertise of the Art Nouveau, Art Deco, and Beaux-Arts periods and critiqued the first chapter of this book. Rosina A. Florio, executive director of The Art Students League of New York, made certain photographs available illustrating classes in session during the time of Bessie Pease Gutmann. It was, however, at the John Adams and James Madison buildings in Washington, DC, that we received hospitable receptions and were guided through volumes at the Library of Congress and the United States Copyright Office. Many individuals were

helpful and provided invaluable advice and exercised great patience with us as we conducted extensive research. Notable were Joseph A. Mills, copyright examiner, Library Section, Examining Division, Copyright Office, Library of Congress, and Bernard A. Bernier, Jr., assistant chief, Serial and Government Publications Division, Library of Congress.

Librarians from coast to coast contributed to my research and more often than not extended their search beyond my queries, thereby adding to the completeness of the raw data. In particular the following people provided grateful assists: Morey Berger, branch librarian of the Monmouth County (NJ) Library; Venice (FL) Public Library; the Art and Music Department of the Los Angeles Public Library; Renee Tarshis and Carol E. Colon of the Bay Area Reference Center (BARC) of the San Francisco Public Library; Evelyn Greenwald, Director, South California Answering Network (SCAN) of the Los Angeles Public Library; The Free Library of Philadelphia; Elizabeth M. Perinshief, supervising librarian (Ret.) of the Burlington County (NJ) Library; Dr. William Omelchenko, college archivist, Hunter College; Janet Tuerff, New Jersey State Library; the New York Public Library; Department of State (NJ), Division of Archives and Records Management, Archives Section; Loyce M. Pleasants, director of Central Library, City of Los Angeles; Donald Dietrich, head librarian, and Sharon Aurick, Reference Department of the Mount Holly (NJ) Public Library; and the United States National Archives Center, Bayonne, New Jersey.

Certain dealers in collectibles and fine art prints kept me informed of new discoveries and sent photographs. Notable among them were Fran and George Sherman of Green Valley Antiques (CA) who gave unstinting cooperation by supplying me with innumerable photos and whose help was invaluable, Paulette and Pete Perlman of Paulette's Antiques and Collectibles (PA) who were personally encouraging and unhesitatingly helpful, Betty and Rick Hall of Touch of Past (NC), Sherrie Kirkland of Kirkland's Kollectibles (NE), Laurie Lake of Attic Treasures (NY), Mark J. Hart of Love & Antiques (NY), Ceil and Lou Kleinman of C & L Antiques (FL), Marci and Bob Weissman of Neat Olde Things (NJ), and Joanne Pickering of Pickering Prints (CA) all gave assists over the years.

I also wish to thank the following institutions and individuals for their helpful replies to my questions which were important to the continuity of the book: Michael Cipollino, chief clerk, Surrogate's Court, Suffolk County, New York; Norman Goodman, county clerk, New York County, New York; Walter F. Causey, associate economist, Department of Commerce, State of New York; Bill Cote, editor, "Barr's Post Card News"; Doris Ann Johnson, editor, "Antique & Auction News"; Elena S. Freccia, Consumer Relations, Ohio Art Company; Pennsylvania Academy of the Fine Arts; The Art Center of the Oranges, East Orange, New Jersey; The United Presbyterian Church of America; researcher Jane Adams Clarke; the Mount Holly (NJ) Cemetery manager, John Phares; and Suzannah A. Jones, secretary, See's Candies, Inc.

The community of Mount Holly, in Burlington County, New Jersey, is recognized for providing the art world with the first official public attention accorded Bessie Pease Gutmann. On May 21, 1988, the town saluted one of its former citizens. It was on this day that a home, once occupied by the Pease

family, was designated with a plaque honoring Bessie Pease Gutmann. In addition to the scores of anecdotes and memories that were shared on this day, certain individuals and groups contributed significantly to its success: Jeannette Taylor and Marion Anderson of the National Society of the Colonial Dames of America in the State of New Jersey; Betty and Marion Livesey, program committee; Carol B. Kensler, president of the Mount Holly Historical Society; Mary Lewis Smith, district clerk; George Schroon, clerk of records; Mount Holly Presbyterian Church; and Karin and John Yetman who opened up their Historic National Register home on 34 Brainerd Street in the town of Mount Holly, New Jersey.

Without the published sources of artwork, the generous help and the unhesitating granting of reproduction permissions by a long list of businesses and publishers, this book would be incomplete. Notable are: The Hearst Corporation, Best & Company, McCall's Magazine, The Crowell Publishing Company *(Woman's Home Companion)*, The Pictorial Review Company, Dodge Publishing Company, The Century Publishing Company *(St. Nicholas Magazine)*, The Pearson Publishing Company *(Pearson's Magazine)*, The Newark (NJ) News, A. G. Hyde and Sons, Cosmopolitan Print Department of *Cosmopolitan Magazine*, The Osborne Calendar Company, The Curtis Publishing Company *(The Ladies' Home Journal)*, Brown & Bigelow, Dodd, Mead and Company, and Swift and Company.

I am indebted to authors S. Michael Schnessel and Ann Barton Brown, whose works and writing styles influenced me. I am also grateful to Wallace-Homestead Book Company, who sincerely believed in the need for this book and whose staff members guided me to the book's conclusion.

To those I have inadvertently neglected to mention, my profound apologies—perfection was never one of my virtues. All of the aforementioned have helped to accomplish my initial goal—to give artist Bessie Pease Gutmann the recognition she deserves and the status in the world of American art that has so long been denied her.

Bessie Pease Gutmann 🪶 Her Life and Works

Introduction

IN THE EARLY PART of this century, one painter of adorable children so captured the imagination of the American public that her prints appeared in almost every home. Her fame spread to England, across Europe, Japan, Australia, and South Africa, with admirers exclaiming over the realism and natural charm of the works of Artist Bessie Pease Gutmann. She was referred to as "the true delineator of child-life. . .";[1] "one of the foremost painters of babies that the present day has produced. . .";[2] "America's most famous baby artist. . ."[3] yet her name is absent from the listings of artist publications and cannot be found in the bibliographies of American illustrators.

There was indeed a lack of awareness of the great women artists of the past, and art historians of the Victorian era and the era that immediately followed must take the blame. The chronicles of that period, influenced by a cultural milieu which isolated women on a pedestal formed of moral concepts, relegated female artists to the footnotes where they remained until very recently. Ignoring the careers of these female artists cannot change the long history of their works.

This is the account of a very special person who defied the rigid traditions of the time, conquered obstacles that seemed unconquerable, and in doing so retained her charm, gentleness, poise, and sense of humor. Bessie Pease Gutmann was a three-dimensional person who was a woman, wife, mother of three children, and an artist whose work is unparalleled and is continually being discovered and rediscovered. This was certainly a woman-artist *for all times.*

Women born in the 1800s were faced with limited choices with respect to their future—a career or marriage! If they chose a career, it was readily understood that few fields were open to them, and many areas of advanced study were unavailable to them. If they chose marriage, then years of child-bearing, keeping husbands happy and contented, raising and caring for children, and taking care of a home, would be their destiny. Many of the most talented women of the day became discouraged by the seemingly impossible obstacles society placed before them when they chose both marriage and a career. Most demurred and settled for either one or the other. We look today with dismay at artist Charlotte Harding (Brown), the prolific

student of Howard Pyle and the protegee of Alice Barber Stephens, who was lost to the art world when she married in 1908. She did, in a fit of house cleaning, burn her work, and in 1947 stated ". . . everything else went into a bonfire. I had no reason to keep anything for that phase of my life had ended. . ."[4] Rare was the woman who chose a career, a marriage, and children. Bessie Pease Gutmann chose all three.

Victorian society clearly defined the roles that women were to fulfill and, unfortunately for American society, few women took exception to the established standards. By the time Bessie Collins Pease was born in 1876 the age of women's liberation was only in its 30th year, having begun with the first women's rights convention at Seneca Falls, New York in the late 1840s. Formal education for women generally concluded with graduation from grammar school or with minimal secondary school attendance. Schnessel, in his gem of a book on the acclaimed Jessie Willcox Smith, points out that "many significant advances had been made in the teaching acceptance of female artists. . ." and that the City of Philadelphia, "despite its rigid social climate which was so overly concerned with protocol and class standing, was among the most advanced cities in the world with regard to artistic opportunities for women. . ."[5]

It was the renowned female sculptor, Harriet Hosmer, who in the 1850s averred that the United States did offer much to aspiring women: "Here every woman has a chance, if she is bold enough to avail herself of it, and I'm proud of every woman who is bold enough. I honor every women who has strength enough to stand up and be laughed at if necessary. That is the bitter pill we must all swallow in the beginning; but I regard these pills as tonics quite essential to one's mental salvation."[6] These profound words must have been heard and heeded by Bessie Pease Gutmann.

Bessie Collins Pease possessed an undauntable determination and a strong will. She had made up her mind early in life to be an artist and refused to take the road of spinsterhood as did so many of her contemporaries. Likewise, she shook off the pattern of the times that confined women to male-made rules and had a happy love-marriage, had her children late in life, and saw her artwork achieve a popularity and financial success which far surpassed most of her predecessors and contemporaries.

Throughout her long, productive life she sought realism in her finished work whether her subjects were adults or children. Her success stemmed from the combination of her exceptional talent and her determination to depict happy children. It was some time later in her career that a writer describing her work commented, "her children are flesh-and-blood children with nothing of the wingless angel about them. She paints youth full of life, beauty, full of the spirit of infancy and the gaiety of early years."[7]

Bessie Pease Gutmann lived and thrived through the great period of art history. The Beaux-Arts Period began in 1875 and ran parallel with the Art Nouveau movement until the Art Deco period began in 1926. It was, however, in the field of illustrative art that she achieved her greatest success and popularity. She was part of "The Age of Innocence" and "The Golden Age of Illustrators," for during the course of her fifty-year career she was to produce over 600 published works, most of which achieved such popular public acclaim that it was unmatched by artists of the time. Her work

remains popular and, in fact, timeless. Her natural-looking paintings of youngsters and babies doing what comes naturally have universal appeal.

In the pages that follow you will get to know this beloved American illustrator whose artistry is acclaimed internationally. Her illustrations are a legacy that has been used, and will continue to be used, to lead generations through her art *into a gentle world*.

$\mathbf{\approx}$ 1 Woman, Mother, and Artist

ON APRIL 8, 1876, Bessie Collins Pease was born at the home of her parents in Philadelphia. She was the fourth of five children born to Horace Collins Pease, a traveling tobacco salesman whose Connecticut family were descendents of the Mayflower, and his wife Margaretta Darrach Young Pease, whose parents were from the Parish of Feughnvale, County of Derry, Ireland. Within a few months the family moved to Mount Holly, New Jersey, where they resided for the next twenty years and where the youngest child, Mabel, was born.

Bessie Collins Pease was a happy child who grew up with loving parents, a brother and three sisters to play with, successful public school experiences, and happy times at the Mount Holly Presbyterian Church Sunday School. Her first school experiences in Mount Holly were in "The Old School House," a one-room schoohouse (Fig. 1-1) which was almost directly across the street from where she lived. Perhaps the only traumatic experience that she had as a child, and one that plagued her throughout her life, was the incident that occurred at the age of six (Fig. 1-2). "While playing outside with other girls and their dolls, a thrown stone struck her doll causing some chips to fly into her eye. This caused an injury to her left eye (greenish-gray in color, the right eye was brown in color) which left a tiny imperceptible scar.

The damage to her pupil and the subsequent seven percent vision loss did not affect her artistic prowess. It was her eyes, however, which became a source of many problems for her, and which eventually caused her to cease her art activities. As a young girl it became necessary for her to wear glasses and as her sight became weaker she moved to bifocals, then trifocals, until finally in the late 1940s she became partially blind, and in the early fifties the damage done by arteriosclerosis caused her to give up painting for publication completely."[8]

The mother Pease first became aware of her daughter's talent when she was a pre-schooler. "One winter day at their home at 34 Brainerd Street in Mount Holly, New Jersey, mother Pease glanced at her four-year-old drawing pictures on the steam, caused by the kitchen stove, on the window pane."[9] Window writing and drawing was a favorite pastime for the young

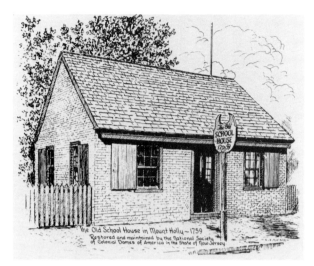

FIG. 1–1 The Old School House (Brainerd School) in Mount Holly, New Jersey. Built in 1759, it was the first building in which public education was offered in 1765. It was restored in 1959 by the Colonial Dames of America in New Jersey. (Courtesy of Colonial Dames of America in New Jersey)

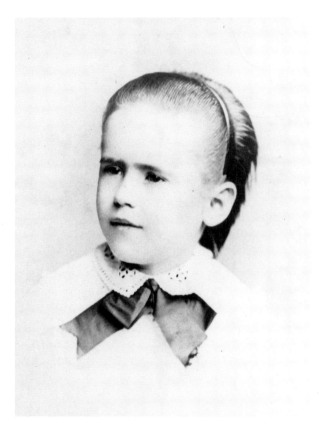

FIG. 1–2 Bessie Collins Pease at the age of six. (Courtesy of Lucille Gutmann Horrocks)

children of the times, but for this young child it became a way to express her natural talent. This talent matured through the encouragement of her parents and the teachers in the Mount Holly Public School System and is evidenced by the notebooks of drawings she maintained in her early years (Fig. 1-3).

"Mrs. Gutmann recalls a time when she was attending Grammar School

that she and another girl conceived the idea of originating some attractive pictorial advertisements to sell to commercial houses. Their first venture was with a soap company. She painted a very pretty picture of a young girl with a wonderful complexion—a result, of course, of the use of so-and-so's soap. The letterpress was supplied by the other girl, and when the advertisement was complete they dispatched it to its destination with fervent hopes of acceptance. 'Days passed and we heard nothing. Then one morning the postman brought an envelope addressed in a strange hand, and on opening it out dropped a five dollar bill, together with a letter thanking us for the picture and saying the firm would make use of it shortly. We skipped round the room in high glee, and began to calculate how much we should be able to make at the same rate of payment. And the next day I hurt my thumb and couldn't paint a stroke, and by the time it was well again our enthusiasm had evaporated. I never saw the advertisement reproduced, and we never tried again.' "[10] Performing artwork for the commercial field would, however, become one of the first contractual positions held by Bessie Collins Pease several years later.

The early and formative years of the young Miss Pease (she never liked to be called "Bessie" and was called "Bess" by friends and family members) were by no means ordinary. Unlike many of her contemporaries, she knew she was to be an artist very early in life. She describes one of her first experiences, the one that determined her to become an artist, thusly: "I went

to school in New Jersey and while there I heard about a picture exhibition that was to be held in Chicago. I was very anxious to send in a picture, and thought long and seriously of what the subject should be. I made a drawing of a girl trying to catch a horse with a pan of chaff, and entitled it 'Not to be Caught by Chaff!' I was too nervous to write my signature under it, as I felt sure I should make a blob, so the teacher signed it for me. It was dispatched to the exhibition, and after several days of considerable anxiety I heard that it had been hung. I was the proudest girl in the world and wanted to go to Chicago to feast my eyes on the picture in its glorious position, but of course I never did. The hanging of that picture, however, determined me to become an artist, and I worked very hard."[11] This vivid recollection of her first important drawing was totally uncharacteristic of Bessie Pease Gutmann, for during the course of her entire personal and professional life she did not seek public attention nor recognition for her artistic achievements.

Although "Not to be Caught by Chaff!" was the first picture by the young artist to be presented to the public, there is considerable evidence to establish the fact that she demonstrated an art talent at a very early age. The origin of her talent may be traced to her mother whose early notebooks contain pencil and charcoal drawings which show skillful line renderings of landscapes and farm buildings as well as perspective skills. These pencil drawings (Fig. 1-4) indicate some formal schooling and training and certainly explain why the family readily recognized, supported, and encouraged the formal studies of a daughter with obvious talent.

Bessie Collins Pease became so advanced and skilled in her artistry that at the age of twelve she was "hired" by one of the Mount Holly school teachers to give art lessons. Bessie Pease Gutmann later described the experience: "I was earning money to coach the teacher in art and I began to build castles in the air. . . what if she took *two* lessons a week instead of one? or *three?* or *four?* or *five?* I had visions of becoming rich. . . only to come to the harsh realization, very soon, that my benefactor was a teacher and didn't have that much money."[12] By the time graduation from Mount Holly High School came about Bessie Collins Pease was already recognized as one whose work had begun to fulfill the promise which her early work had disclosed. By the age of sixteen she had entered many amateur competitions and had won many prizes for the excellence of her work. It was only natural that she would seek to continue her formal art studies by attending a school in Philadelphia, which was regarded at the time to be the cultural and art center of the United States. She chose to attend the Philadelphia School of Design for Women (now the Moore College of Art) and began her formal training in 1893 at the age of seventeen. The school, which had been attended by artists Charlotte Harding Brown, Grace Gebbie Drayton, Edith C. Pyle, Harriet Sartain, and Jessie Willcox Smith, had a profound effect on Miss Pease. The fervor with which she sought to improve her skills and techniques can be understood when one looks at her daily commute. In order to attend classes she had to walk from her home on Brainerd Street to the Erie Railroad station in Mount Holly, board a train to Camden, take the ferryboat across the Delaware River to the Philadelphia waterfront, and then ride a horse-drawn trolley to the Philadelphia School of Design for Women on Broad and Masters Streets—a two and a half hour trip each way.

Head of the Madonna.

She entered the school during Artist/Principal Emily Sartain's revitalization of the curriculum and faculty.[13] "Her advent made a marked change in the management of the school. At the time, drawing from the flat by beginners was finally abolished. . . The old course in art as in design had placed undue emphasis on and given excessive time to the mechanics and mathematics connected with perspective and geometry."[14] Emily Sartain was an artist in her own right who came from a distinguished and active family of artists. She studied painting in Paris and Italy and shared a studio for a while with the great American impressionist, Mary Cassatt, her friend and traveling companion. Her studies at the Philadelphia Academy of Fine Arts were impressive and it was there that she came under the stimulating and innovating influence of Thomas Eakins, who became her close friend. One of the innovations that Emily Sartain established was a Life Class, and work in the class sessions impacted on all students, including Miss Pease. The emphasis by the instructor was on the student's ability to see the human form as a means of expressing art forms. "An eye trained to accuracy and to delicate discernment of subtlety of line, and form and color-trained by study of the swaying, melting, yet strong and meaningful curves of the human body can quickly seize and express the characteristics of simpler forms," and further, Emily Sartain interjected "it is a recognized necessity for the illustrator. . ."[15]

The distinguished instructors that Miss Pease came in contact with were the "new breed" that Emily Sartain had recruited. They were the vanguard

Woman, Mother, and Artist

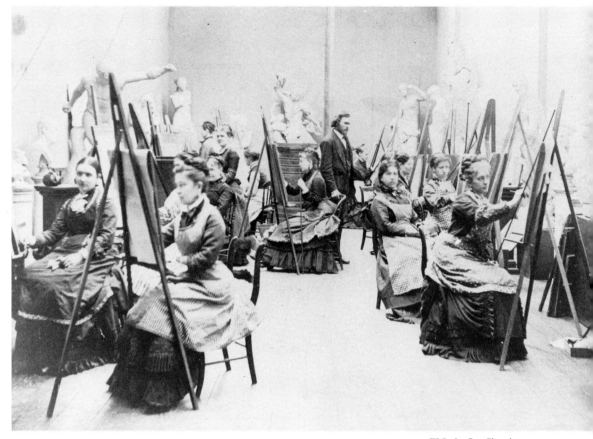

of the new age of realism in art and in raising illustrative art to being recognized as a true art form. The classes of Alice Barber Stephens, the most successful woman illustrator of the time, were in the instructional area of "Drawing and Portrait Painting from Life," "Pen Drawings for Illustration," and "Full-Length Life." Stephens' instruction so impressed the young artist that she adopted the "balloon" type signature of her instructor and signed all of her early work with this characteristic designation. It was, however, in the classes of the celebrated School of Realism Artist Robert Henri, that a profound impression was left on her. Henri's classes in "Drawing from the Antique" and "Composition" were exciting for the young student and she demonstrated in some of her later published and unpublished works that she was a versatile artist and an attentive student. It was undoubtedly her experiences at the Philadelphia School of Design for Women that shaped her ideas and approaches to her art subjects throughout her career (Fig. 1-5). The whole direction and emphasis on the fine arts as a basis of both professional and fine art education, which Emily Sartain brought to the Philadelphia School of Design for Women, gave Bessie Collins Pease's career a strong start.[16] She concluded her class work in 1894 with unswerving plans to continue.

William Merritt Chase, the great American impressionist painter, had just

opened a new school in New York City and was advertising for students. The New York School of Art opened its doors in 1896 at 41 Union Square West, and Miss Bessie Collins Pease was one of its first students. Very little is known of the school. It failed in 1906 and most of its records were lost. It *is* known, however, that the young Miss Pease attended several classes which were conducted by the master himself, William Merritt Chase. By this time, at age nineteen, she was described as, "tall, slender, dark hair, attractive and having a sense of humor."[17] She and her younger sister Mabel had decided two years before that New York City would be the place to live and pursue their careers. Mabel wanted to become a teacher and attend City College. Bessie Pease was determined to have her own art studio and continue her education. Their father, Horace, was not a man of great wealth but he and his wife, Margaretta, were strong supporters of education, "so money was borrowed from his first cousin, William C. Whitney, the American financier."[18] In the spring of 1896 the two women moved into a studio-apartment at 140 West 126th Street.[19] Two years later, when both had completed their studies, they moved in with their parents who had relocated from Mount Holly to 2322 7th Avenue, New York City (Fig. 1-6).

Options open to women to earn money in the late 1800s were scarce, so Bessie Pease had to content herself with painting name cards, place cards, portrait sketches, free-lancing illustrations for local newspaper advertisers, and designs for the covers of a ladies' magazine. Unfortunately, none of this work was signed nor did it stand the test of time. She did receive a commission in 1899 from a ladies group in Atlanta, Georgia, who were preparing a peace jubilee banquet to honor the ladies of President William McKinley's party. "The Atlanta ladies desired a souvenir badge to be placed at each plate and they invited designs. Miss Pease was one of those who answered the request. The badges were to consist of a painted medallion head and it was desired to have each one represent some person connected with the history of the country, but as it would require fifty this was abandoned and the artists were asked to present original designs. Those of Miss Pease were accepted and she was directed to send them at once. An idea of what this meant may be gained when it is known that the order was received on Thursday and the badges must necessarily leave here on Monday. The contract was faithfully carried out, however, and the souvenirs left by the early mail yesterday. The badges were beauties. Each head was of a different design painted on a circular piece of cardboard and attached to a ribbon either red, white or blue in color. The young lady is certainly entitled to great credit for her success in securing this honor. She has already received one message of congratulations in the shape of a telegram from Hon. William Venable, president of the Georgia Senate."[20]

Perhaps this was not what one might refer to as an auspicious achievement by a budding artist, however, the experience did confirm that her artwork was competitive. The restrictions placed on women in nineteenth century America did not serve to raise the level of the female artist's self-esteem. A writer of the period explains it this way: "She has been regarded somewhat as the disease of civilization, much in the same manner that the pearl is said to be the disease of the oyster, and held as a precious bauble of inutility."[21] It was by sheer determination, tenacity, dedication, and talent

FIG. 1-6 Mount Holly Herald staff artist's rendering of Miss Bessie Pease in 1896. The reporter noted "Miss Pease has won many prizes for the excellence of her work . . . and . . . has taken a studio in New York where greater opportunities are afforded. . ." (Courtesy of Mrs. John C. Gutmann, Sr.)

MT. HOLLY ARTIST HAS WON MANY PRIZES.

MISS BESSIE PEASE.

Miss Bessie Pease, of Mount Holly, a young artist whose work has been widely noticed of late, has taken a studio in New York, where she will pursue her studies.

Miss Pease has been a pupil of some of the most noted artists in New York and her work has already fulfilled a promise which her early efforts disclosed. In amateur competitions Miss Pease has won many prizes for the excellence of her work. She has shown much originality and strength in her lines and coloring. It is for the purpose of continuing her study in technique that Miss Pease has taken a studio in New York, where greater opportunities are afforded.

that the female artists, such as Bessie Pease Gutmann and her contemporaries, Mary Cassatt, Jessie Willcox Smith, and others were successful in their chosen art fields. It was characteristic of Miss Pease to never be daunted nor to lose her cheerfulness and sense of humor. As an art student, she personified the American girl of the times by her determination to pursue career studies and maintain her poise and graceful dignity. She also made sure throughout her lifetime that her copy of Emily Post's "etiquette" was close by.[22]

Encouraged by small achievements, she decided to continue her formal studies by enrolling in classes at the Art Students League of New York in

1899. At the age of twenty-five, without any recorded proposals of marriage, Miss Bessie Collins Pease was considered by society to be on the road to spinsterhood. Unlike many of her contemporaries who chose spinsterhood in order to pursue an art career, she realized that her future included marriage, family, *and* an art career—a quite unheard of goal in life and regarded by most to be pure fantasy.

The decision to enter training at The Art Students League of New York was to be the turning point in her life and the beginning of the fulfillment of her dreams and desires. The Art Students League, housed in the American Fine Arts Society building at 215 West 57th Street in New York City, conducted its classes on the third floor with studio classes held on the fourth floor. Such notable graduates included Maud Humphrey, Violet Oakley, Katherine Pyle, and Olive Rush.

The opportunity to study for the next two years under such art giants as Kenyon Cox, Walter Appleton Clark, Arthur W. Dow, Joseph DeCamp, Frederick Dielman, and H. Siddons Mowbray, proved to be one that shaped her attitudes and sharpened her skills and techniques for her future life as an artist. The Life Class of Kenyon Cox (Fig. 1-7) where drawing from life and from the antique cast was of particular interest to the young artist, helped shape her mastery of the charcoal pencil and ink wash. Cox, the muralist and sometime illustrator, was a product of the Ecole des Beaux-Arts of Paris and a disciple of Gerome's Neo-Classicism. Arthur W. Dow (best known as the former teacher of Georgia O'Keeffe) in his Progressive Class in Composition used a definite Art Nouveau approach and introduced his students to Japanese art and to the Japanese system of composition. Her introduction to illustrative art came from the afternoon classes in Illustration in Head and Still Life. Frederick Dielman's ten lecture series on Perspective and the morning classes of H. Siddons Mowbray in Drawing and Painting from Life rounded out the complete two year curriculum of study for her. During this time her art portfolio began to brim full of examples of her versatility and skills.

Her classes in Life, conducted by Cox, were exciting and had considerable influence on her. Her work in this class demonstrated an amazing amount of maturity and discipline, deftness with pencil, charcoal stick, and ink washes, and "although typical of the period (1895 – 1905) are of superior quality."[23] The event which changed her life probably occurred in the Head and Still Life Class conducted by Joseph De Camp. It was in this class, one of the few at The Art Students League which did not separate men from women, that she came in contact with a fellow student, Bernhard Gutmann. After observing her work and the contents of her portfolio, he invited her to work with him and his brother Hellmuth. They were planning to form a business operation to handle fine art prints and advertising.

Hellmuth and Bernhard Gutmann were a personification of the American dream. Alarmed by the warlike sounds emanating from the Kaiser in Germany and encouraged by their inventor brother Ludwig, who was living in St. Louis, they joined the hordes of Western Europeans immigrating to the United States in 1892. They settled in Lynchburg, Virginia, where Bernhard became the first Supervisor of Drawing and Art in the Public Schools of Lynchburg and an Instructor of Art at Randolph Macon College.

FIG. 1–7 Kenyon Cox's class in "Anatomy and Figure Drawing" at the Art Student's League in 1899. (Courtesy of Art Students League of New York)

In 1899 Hellmuth moved to New York City and took a job as a cashier in a retail business. The early training of Hellmuth as an etcher-engraver and the formal art training of Bernhard at the art academies of Dusseldorf and Karlsruhe and subsequently Haarlen, Holland, encouraged them to form an art print business. A business venture in the art field proved to be a good decision. The art trade was just beginning to flourish and few such businesses were active. The firm of Gutmann and Gutmann was formed in 1902 with Hellmuth providing the business knowledge and Bernhard the art knowledge.

Free-lancing was not financially rewarding for Bessie Collins Pease, and the fact that she was still living with her parents prompted her to accept the invitation offered by Gutmann and Gutmann. She began work in early 1903 "as a commercial artist."[24] She enjoyed commercial art and her drawings attracted the attention of others who needed such work. Advances in the art of printing, combined with a healthy economy and the growing public demand for art, had opened up thousands of opportunities for a capable

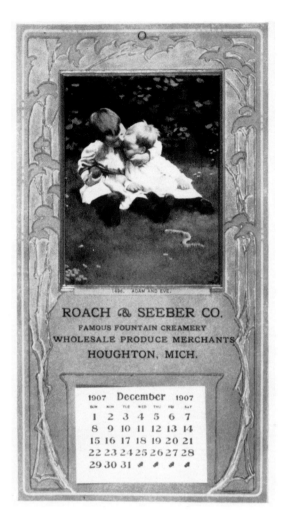

artist in the field of book, magazine, poster, and trade-card illustrations.[25] At just about the time that she decided to accept some of the proffered commissions, she was advised by Hellmuth Gutmann that she was much too good to continue doing illustrations for advertising but should move on into the fine art print field.[26] In early 1904 Bessie Collins Pease broadened her work field and took on magazine article illustrating, book illustrating, prepared work for calendar illustrations, created work for art prints, and accepted commissions for her art with outside firms.

Early commissions with The Osborne Company of New York for calendar illustrations (Fig. 1-8), book illustrating commissions from Dodge Publishing Company, The Century Company, Best & Company, and the Robert Chapman Company of New York (Fig. 1-9), and the illustrations of articles appearing in several of the most popular magazines of the period, kept her quite busy. In just a few short years she had illustrated eight major books for Dodge, with the most popular and widely read *Alice's Adventures in Wonderland* by Lewis Carroll being her first major commission job (Fig. 1-10). She achieved recognition as an illustrator of note by the year 1906.

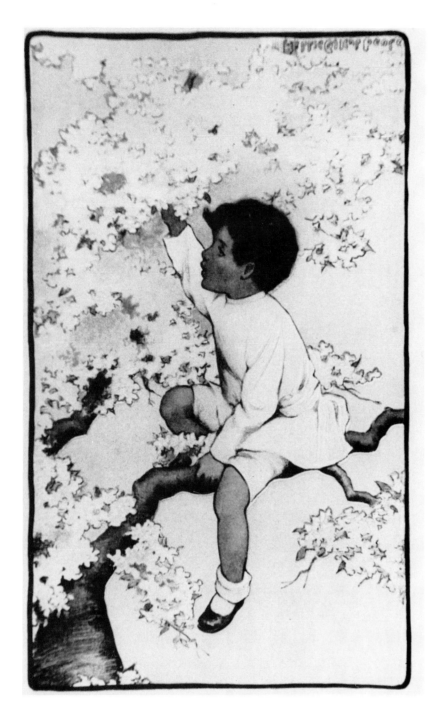

FIG. 1–9 Frontispiece from *A Child's Garden of Verses* by Robert Louis Stevenson. New York: Dodge Publishing Company, 1905

Time and true love took care of the next important episode in her life when, after an appropriate period of courtship, Hellmuth Gutmann (nine years her senior) asked for her hand in marriage. They were married on July 14, 1906 in her former home (which now belonged to her brother-in-law, Edgar A. Alcott) in Mount Holly, New Jersey. The following account of the wedding appeared, in part, in *The Mount Holly Herald* on July 16, 1906:

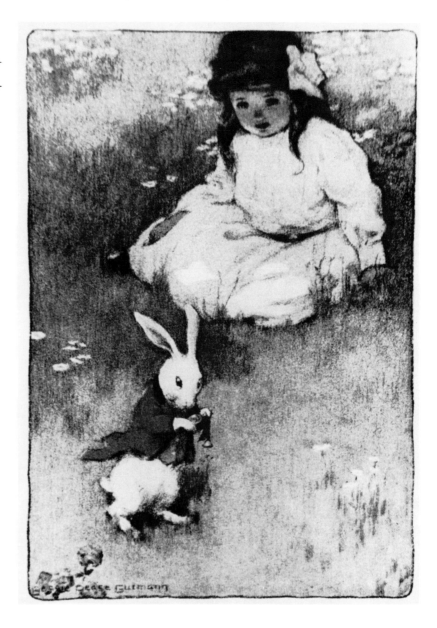

"The ceremony was performed by Rev. Dr. Charles J. Young, pastor of the Presbyterian Church of the Puritans, in New York. At half-past four o'clock the bridal party entered the parlor at Mr. Alcott's home, preceded by his two daughters, Misses Margaret Allen Alcott and Elizabeth Harker Alcott who carried the end of long white ribbon streamers. Miss Mabel B. Pease, dressed in cream brussels net over pink, and carrying a shower bouquet of pink sweet peas, was maid of honor. The bride was dressed in white messaline, Duchess lace, and carried a shower bouquet of white sweet peas (Fig. 1-11). She was attended by her father. The best man was Bernhard Gutmann.

The ceremony was witnessed by about 100 friends of the families from New York and this neighborhood. The wedding feast was served by

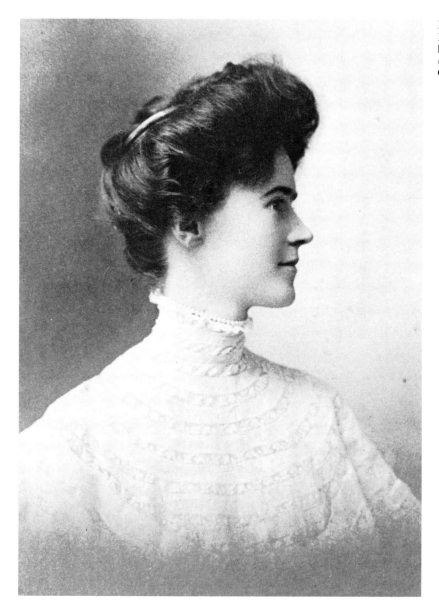

FIG. 1–11 Photo of Bessie Pease Gutmann in her wedding gown, c.1906. (Courtesy of Alice Gutmann Smith)

Hildebrecht, of Trenton. The happy couple received many telegrams of congratulations. One of them was a cablegram from the father of the groom who is in Hamburg, Germany. A peculiar incident connected with this message was that it arrived at the house during the ceremony. Mr. and Mrs. Gutmann will go abroad for awhile and will then take up their residence in New York City."[27]

The marriage was to be sustained for forty-two years and would produce three children: Alice, Lucille, and John. It was truly a marriage of love, and it was a perfect match for both, "obviously a true love affair and I never heard an unpleasant word exchanged between my mother and father. . . my mother was a beautiful person who was a quiet and private individual with a

genuine love for childen . . . my father was a special person who was gentle, reserved, and very much interested in wildlife . . . he maintained beautiful gardens. . ."[28]

The course of Bessie Pease Gutmann's life and career was altered dramatically. Within three years of her marriage two babies had arrived, the family moved from the boarding house in New York City to a new home on West End Road and Wyoming Avenue in South Orange, New Jersey, and there was a radical departure from her assignments at Gutmann & Gutmann. She was now to prepare artwork for fine art print trade. Fortunately, the art print business of Gutmann & Gutmann was flourishing and was destined to reach even greater fiscal success. She was now a loving wife, a beautiful mother, and would soon be recognized as one of the leading portrayers of children and their activities in the United States and Europe. She could now express motherly love—the warmth, joy, richness, and fulfillment of life only a mother could see was no longer a vicarious emotion. Motherhood was a personal joy for her to share with the world through her artistry. In her there was the confluence of two of the most noble strains in humanity—the mother and the artist. Both qualities were creative, and both were striving to express their knowledge and outlook. These characteristics caused one English magazine writer in 1908 to assert, "The true delineator of child-life is so rare that little wonder may be expressed at the increasing attention which the work of Mrs. Bessie Pease Gutmann is attracting. Her studies of children are now almost as well-known in Europe as across the water. She is an artist whose work has been very little influenced by other masters and whose style is founded upon that of no other painter. Her work is free and unconventional—her children are flesh-and-blood children with nothing of the wingless angel about them. She paints youth full of life, beauty, full of the spirit of infancy and the gaiety of early years."[29]

Bessie Pease Gutmann was creating not just with charcoal stick and brush but also out of a real love for children. She had indeed created a new and distinct type of childhood. Her success was not the result of some public relations efforts, but came from the combination of her exceptional talent and determination to depict happy children exactly as they were— sometimes naughty, sometimes disheveled, but always pink-cheeked, plump and delightful. Her works became like a breath of fresh air to those who sought her work and who had grown accustomed to seeing children portrayed as solemn, formally dressed miniature adults. Her models were immediate and found everywhere, beginning with her own children. She sketched Alice at five weeks old (Fig. 1-12) and Lucille at two months old. There was never a shortage of models. According to her, "everyone has babies, you know; my friends had them and I had three—there were always babies for models!"[30]

The years that ensued were joyous and rewarding years for this quiet, dignified woman. She had defied traditions of the times and became a successful wife, mother, and artist (Fig. 1-13). Not a driven artist, but certainly a disciplined one, she maintained a regular work schedule which began in mid-morning and continued until late afternoon. Her studio, on the second floor of their home in South Orange, was well-equipped and featured a skylight, fireplace, and a real tiger rug. Gutmann worked at an

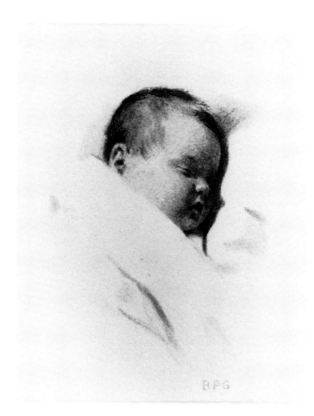

FIG. 1–12 Pencil sketch of Alice King Gutmann (born October 24, 1907) at the age of five weeks. (Author's collection)

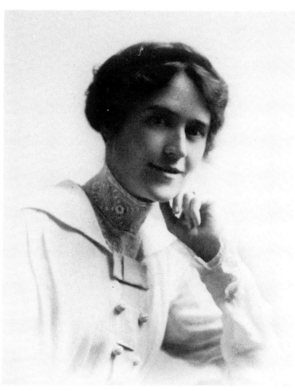

FIG. 1–13 Studio portrait of Bessie Pease Gutmann, c. 1908. (Courtesy of Mrs. John C. Gutmann, Sr.)

19

easel that was placed in the southeast corner of the studio, facing the only entry door on the opposite wall that opened up onto a corridor. An unusually heavy carved ornate chair was positioned to her right and opposite the fireplace. This figured in a particular artwork that was almost a self-portrait of her and her newly born son John (born April 6, 1918 when the artist was forty-two years of age) and it appeared as a fine art print in 1919, aptly named "The Great Love." The door to the studio served as both an exit and entry and was always open. This allowed her children the freedom to wander in and out and also permitted the mother to keep an eye on them.[31]

The collaboration of the wife-artist and husband-publisher proved to be an effective one as the Gutmann & Gutmann Company art print business flourished and by 1920 they had twenty overseas agents with an annual recorded foreign sales of over $20,000 (Even during World War I they continued to market and ship prints overseas.) It had been decided early in their marriage that the wife-artist would limit her activities to preparing artwork for the fine print trade. She continued to accept commissions to perform outside work from such firms as The Robert Chapman Company of New York, The Hawkeye Pearl Button Company of Iowa, Glendale Knitting Company-The Perry Knitting Company of New York, The Wells and Richardson Company of Vermont, Swift & Company of Chicago, Illinois, Dodge Publishing Company of New York, and The Brown & Bigelow Company of St. Paul, Minnesota.

The sustaining and remarkable factor in the life of Bessie Pease Gutmann, and that which probably accounted for her phenomenal success as a wife, mother, and artist, was that she was not consumed by a desire for fame or public recognition. It wasn't that she avoided publicity nor that she rejected the role of being a public person. It was simply a fact that Bessie Pease Gutmann was too busy enjoying life by doing what she liked to do. There just wasn't time in her life to give interviews, make public appearances, or bask in the adoration that was accorded public figures in the first four decades of the 20th century. In the three known public interviews that she gave over a span of thirty years, her interviewers often commented that "Mrs. Gutmann is adept at turning the conversation from herself to her family or to current topics where her interests center . . ."[32] and "when. . . called upon. . . to obtain a few facts regarding herself and her work, the artist was obviously embarrassed. She frankly confessed that she had never been interviewed before and would rather not be interviewed then. . ."[33] A newspaper reporter in the early 1920s, noting that it was not often that an artist of such importance visited in their area, commented, "Mrs. Gutmann is as modest and retiring over her celebrity as she is gifted with the great genius that won this celebrity."[34] She was a private individual whose early family life and moral training caused her to mature into a gracious, warm, and loving person. She loved her husband and her children to the point of total devotion and her artwork was secondary. She never sought fame for herself and her life attests to the fact that she didn't need it (Fig. 1-14).

An insight into the type of family life found in the Gutmann household in South Orange is the description given of Christmas Eve and Christmas Day as seen through the eyes of the three Gutmann children. "There was no day of greater importance in our lives than the Christmas times that we had with

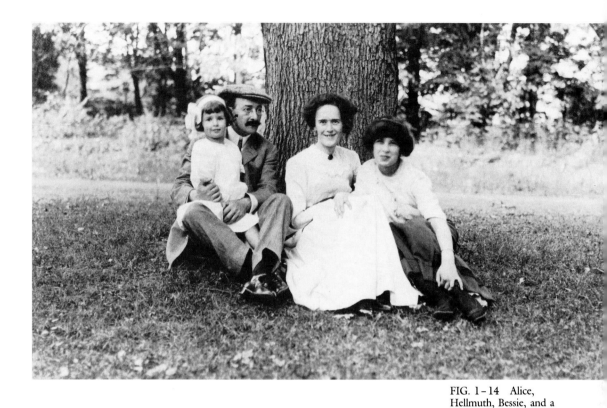

FIG. 1–14 Alice, Hellmuth, Bessie, and a neighbor on the grounds of their home in South Orange, New Jersey, c. 1915. (Courtesy of Alice Gutmann Smith)

our mother and dad. It seemed as if all of the finest things of the entire year came together at this time of year and engulfed us with overwhelming feelings of warmth and satisfaction. On Christmas Eve, mother would recite *'T'was the Night Before Christmas* and we'd all chime in. Grandma Pease (her mother), Auntie Mable (her younger sister), Auntie Peggy (her sister Margaret) and husband, Uncle Walter (Walter Semple, a Presbyterian minister), participated too. On Christmas morning, after all of the merriest of greeting had been offered, we went to mother's studio where our Christmas tree had been decorated with tinsel, ornaments and lighted candles. It was a glorious sight. Huge stockings had been hung on mother's fireplace and they were filled with special treats of nuts and fruits. Despite the fact that our beloved cat, Chinky, had been relegated to the sun porch, we all had a joyous time and day. One of our special treats for the day was at our Christmas morning breakfast where we had shad roe. Later on, our Christmas observations were held on the sun porch and living room, but Christmas was a remarkable, memorable time for us and the memories of such a beautiful time has had a great influence on our lives, then and now."[35]

The ageless quality of her published work and the acclaim with which it was greeted was not a happenstance. Her own lilfe and her unabashed love for children was transmitted from brush to canvas to be shared with all who saw it. She was a master at making quick sketches with pencil or charcoal and carried her sketch book with her to record events on the spot. These sketches would be filed away for some future reference. Like her contemporary, Jesse Willcox Smith, she became a clever photographer, and utilized her small

Kodak box camera to capture those special moments of youngsters around her, asleep or awake, so as to assist her in the portrayal of child studies. She once said, "I prefer originating subjects to illustrating subjects already begotten. I love children and I love to sketch them."[36] All three of her children were born at the Sloan Hospital for Women in New York City where "she would stay for a month after each was born. She enjoyed being with babies and volunteered some of her time as a wet-nurse."[37] The lovely little faces that look out from her work at the viewer, although not portraits, were real life babies and youngsters from a gentle world who could capture one's heart quite quickly. They were the major subjects of her work and separated her from her contemporaries and the child-artists of today.

The Gutmanns purchased property on Ensor Place in Island Heights, New Jersey, overlooking Toms River (Barnegat Bay) on February 6, 1924. Shortly afterward a summer home was built on the property next to the summer retreat built by John Wanamaker for his employees. Many happy occasions were recorded in their second home. It was here that fellow artists Meta Morris Grimball and Eda Soest Doench visited and were entertained. Both artists worked for the Gutmann & Gutmann firm and had achieved considerable recognition for their own artistry. "Aunt Met," as the Gutmann children were to refer to Miss Grimball, collaborated with Bessie Pease Gutmann on the illustration of several books. She also gave a gift to the Gutmann children of an oil on canvas that measured fifteen inches wide and created a perimeter border around the nursery room. This frieze depicted all of the popular nursery rhymes. Mrs. Doench was known not to have much of a sense of humor and Bessie Pease Gutmann liked to tease her about it. Once she was reading a contest ad in the newspaper which required one to fill in the last word. "She read the poem and much to everyone's surprise Mrs. Doench laughed and filled in the last word:

> There was a young lady named Minnie
> Who came from the State of Virginee
> She weighed 88
> In fact, I must state
> She wasn't just thin she was SKINNY!"[38]

The summer home at Island Heights eventually provided a second studio located over a former horse stable. This served as a suitable secluded spot for summers and occasional weekend work. The Gutmanns did have a horse, Silver Heels, which was the children's pony. "Mrs. Gutmann aspired to ride well, her children all did. Someone told her that if she rode eight days in succession she would conquer the timidity she felt about horses. Accordingly, she mounted Silver Heels one morning and started out. . . Silver Heels was the sort of pony who always liked to be headed for home and he balked a bit and upset his rider. Mrs. Gutmann never went back for the other seven lessons."[39]

Gutmann's reluctance for public attention did not prevent her admirers from applauding her in 1915 for *Pictorial Review's* "Artist of the Year Award." Other honors came her way along with continued work assignments by Gutmann & Gutmann and commissions from various businesses and firms. She was busy with her work, with two residences, trips to Europe,

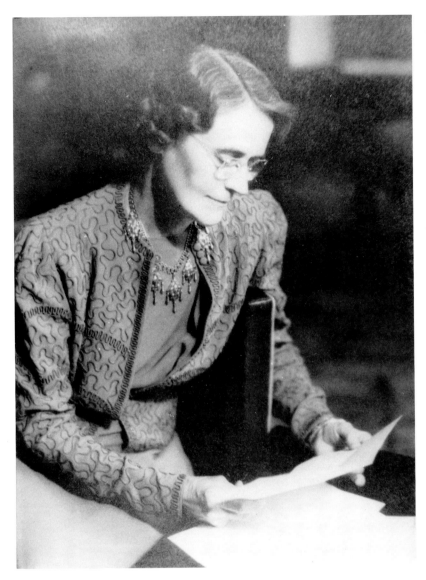

FIG. 1–15 Studio portrait of Bessie Pease Gutmann at the age of sixty-three. A similar photo was donated to the Mount Holly Historical Society in August 1988 by Muriel Bauzenberger whose mother, Mabel R. Burt, was a friend of Mrs. Gutmann. (Courtesy of Ateller von Behr Photographers, N.Y.C.)

the Middle East, and regular vacations to the Florida Keys. No artist of her time, albeit today, could match her productivity of over 600 artworks in a fifty-year period in a range of mediums that included pencil, charcoal, oils, pastels, watercolors, ink washes, etchings and even sculptures. She never, however, considered herself totally accomplished, and she continued studying to sharpen her skills and expand her knowledge.

The impact of the Great Depression was being felt by businesses throughout the country and one of the first to feel its effects was the fine art print trade and its allied graphic arts industry. The firm of Gutmann & Gutmann first felt the effects of the world-wide financial situation when the reports of its foreign representatives began to come in. The foreign market for fine prints began to move upward right after the conclusion of World War I, but as financial resources worsened it began to drop off significantly after 1927.

In 1928 the firm had a total of $5,300 in overseas wholesales and by 1934 sales had fallen to $2,631. The foreign market was a reflection of what was taking place in the domestic market. Employees at the firm were requested to take a cut in salary. "One employee, whom Hellmuth had learned to depend upon, elected to stay with the Company. He, Albert Immergut, thought of nothing but the business and was always willing to be in the office when Hellmuth and Mrs. Gutmann would leave for Island Heights in late spring and stay away until the fall . . . and then leave for Key West after a month at home and not return to South Orange until Eastertime."[40] The business in the 1930s and 1940s was at a low ebb and seemingly the art print trade was finished (except for the "modern art" of the day which Hellmuth Gutmann refused to publish). It was during this period that the name and work of Bessie Pease Gutmann had disappeared, causing one writer of a recent article on Bessie Pease Gutmann to title it "In Search of . . . a lost artist."[41] (Fig. 1-15).

With the passing of her husband on April 28, 1948, and her failing eyesight caused by cataracts and arteriosclerosis, she chose not to paint for publication. She did, however, continue to paint her "relaxation art" of floral and fruit arrangements, still-lifes, and landscapes. On September 29, 1960, at the age of 84, Bessie Pease Gutmann died peacefully in the Echo Nursing Home at Centerport, New York. It was only a short journey back to her childhood hometown where she was laid to rest beside her beloved Hellmuth in the Mount Holly Cemetery.

During her prime years she achieved a popularity and financial success which far overshadowed most of her predecessors or contemporaries. She rose above the rigid Victorian conventions of society and earned her own living both as a single and married woman. Through her artistry, she has come to be regarded as the most beloved American illustrator of all time, whose following is international. The fact that she led people universally into a gentle world, through her art, grants her artistic immortality.

From Corn Flakes to Pajamas— Commercial Art

2 ✎

AT THE TURN of the century, with the appearance of new monthly and weekly magazines and rapid changes in reproduction technology, jobs were opening up for women. As a Philadelphia newspaper in 1912 stated, "As illustrators, women find themselves in a profession where they stand shoulder to shoulder with their brothers in art. For the publisher, the advertiser . . . is interested only in the finished product. . ."[42] In 1903, having accepted employment with the Gutmann & Gutmann firm as a commercial artist, Bessie Collins Pease worked for over a year in the field of advertising and performed a variety of tasks. She refined rough line drawings furnished by advertisers to actually preparing finished artwork for those advertisers that depended on in-house artists. Much of this commercial work was simple, single-line drawings that were prepared for black and white reproduction in the popular magazines and periodicals of the time. This satisfied her because she had already developed such skills with the charcoal stick or pencil that she was regarded as a master craftsperson. She worked with astonishing rapidity and, using strong, fine sweeping lines she could complete a task within a single sitting.

Her advertising art usually appeared in the back pages of a publication and never carried the artist's signature, as was customary at that time. Some of her advertisements were for Best & Company (Lilliputian Bazaar, Fig. 2-1), A. C. Hyde & Sons (Hygrade Pajamas), R. & G. Corset Company, The Can't-Wet Mattress Company, Mrs. Ralston's Clothing Patterns, and Lanitas Toasted Corn Flakes (predecessor to Kellogg's). These ads appeared in such publications as *Pearson's Magazine, The Cosmopolitan Magazine, The Delineator, Woman's Home Companion, Pictorial Review, St. Nicholas Magazine, Everybody's Magazine,* and the Sunday supplement of several newspapers.

Such work was the "bread and butter" of the artist who was attempting to achieve recognition. Since few records were maintained, it is not known precisely how many advertisement art pieces Bessie Pease Gutmann prepared or how many publications used them. She was prolific for the short time she prepared commercial work and it is reasonable to suggest that considerable work is yet to be discovered. Although her work was not

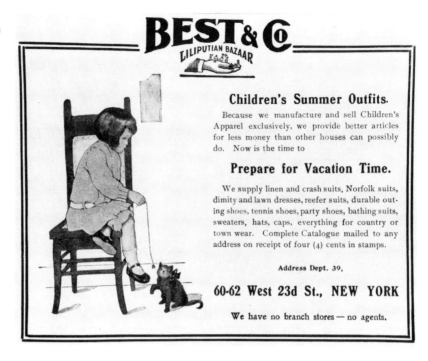

signed, her stylized children are easily identified, and the collector is urged to continue searching for examples of the early work. Her simple line drawings showed a resemblance to the line drawings of Maud Humphrey, but instead of wide-eyed youngsters in floor-length dresses her children were "real" and delineated child-like activities.

The high point in her advertising art career came when, along with her first magazine cover in color, one of her ads appeared on the back cover of the same issue. It depicted a young girl carrying a box of Lanitas Toasted Corn Flakes (in 1907 the name was changed to Kellogg's Toasted Corn Flakes). This ad (Fig. 2-2), in the December 1906 issue of *Pearson's Magazine*, was also the first to carry the signature of her married name, Bessie Pease Gutmann. (Note: the same ad illustration had previously appeared unsigned on page 48 of the April 1906 issue of *The Ladies' Home Journal*). This illustration demonstrates the unique character and quality of her art and for the first time we can see and experience, in the artist's lines and use of color, the warm and tender charm of her images.

Gutmann enjoyed commercial artwork. Most budding artists would have considered such work nothing short of demeaning, but not Mrs. Gutmann. She utilized these simple drawings to express those characteristics in her subjects that were to become identifiable with her own artistry. She was not only working with her favorite mediums but she was also able to continue free-lancing in other fields. Almost thirty years after her commercial art experiences she expressed what she thought of her advertising work: "There's nothing to the idea that an artist aborts his talent through commercial art . . . there's no reason why a picture print or a drawing or painting for an advertisement shouldn't be as beautiful and artistic as a bit of

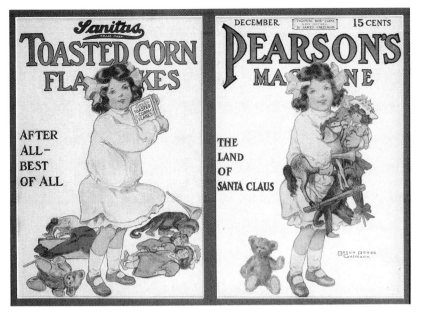

FIG. 2–2 Panel illustrating the front and back cover of the December 1906 *Pearson's Magazine*. This represented the first color advertising work of Bessie Pease Gutmann. This same ad had appeared in black and white in the April 1906 issue of *The Ladies Home Journal*. (Collection of Susan and Warren Wissemann)

art 'for art's sake.' "[43] It would have been totally characteristic for her to have put the same amount of effort into her commercial work as she would into any other.

The black and white ads of her early years have unfortunately disappeared and the original artwork was discarded when the ad was transfered to the printer's plate.

Calendar Activities

The first commissioned work that Bessie Collins Pease received was from The Osborne Calendar Company in 1904. The Osborne Company of New York, one of the largest producers of advertising calendars in the East, was always looking for fresh talent and new art for their expanding business. She was asked to prepare a single illustration for the firm's calendar program and titled her work "Adam and Eve" (1905). This work had all the ingredients that were to appear in her art prints in the years to come. Substituting hard lines for a softer style of charcoal and oil, she pictured two children of pre-school age sitting on a soft green surface of grass with occasional groups of buttercups springing up around them and a background of broad-leaf dark green shrubbery. The little fellow in a white tunic has his arm around a little girl and is pulling her to him for a kiss on the forehead. In his left hand he holds a very red apple and at his left foot lies the remains of a toy snake. "Adam and Eve" captured the hearts of all who saw it and so pleased the Osborne Company that they prepared reproductions of the work to be used on all four sizes of their calendars *and* carried the illustration in their catalog for the next three years.

The editors of *Woman's Home Companion* magazine extended a contract to use one of the Bessie Pease Gutmann's illustrations in their 1908 baby calendar (Fig. 2-3). An opportunity for her art to be reproduced in four

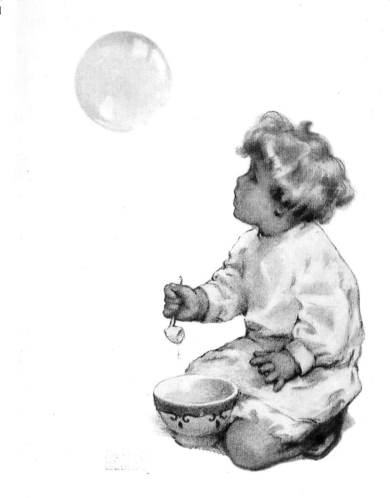

FIG. 2-3 Printer's proof for the August 1907 cover of the *Woman's Home Companion* titled "Bubbles" and used to illustrate the magazine's 1908 baby calendar. (Collection of Mrs. John C. Gutmann, Sr.)

colors and appear in the highly popular baby calendar was flattering and the offer was accepted. The illustration chosen was "Bubbles", which had appeared successfully on the August 1907 cover of *Women's Home Companion* (Fig. 2-4). The magazine editors commented on the selection: "The curly headed 'Bubbles' is the most beloved of our family of babies."[44] The calendar was issued with four panels, as was the custom of the times, and Gutmann was in good company with the other three artists represented: Jessie Willcox Smith, E. A. Ritenour, and Rose O'Neill. The theme of a child blowing soap bubbles was used again for the May 1912 cover of *McCall's Magazine* and illustrated a different child, dark-haired, using a dish basin instead of a bowl but the same clay pipe. The title and theme appeared

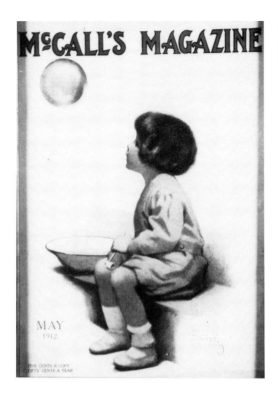

FIG. 2–4 "Bubbles" cover for *McCall's Magazine*, May 1912 issue. (Author's collection)

once again in the 1923 art print "Bubbles" (#714) and pictured a pensive cherub watching bubbles floating in the air (Fig. 2-5).

A commission from the firm of Brown & Bigelow in St. Paul, Minnesota, in 1907 to create artwork for calendar use resulted in at least thirteen different scenes being produced. Unfortunately, neither the company nor the United States Copyright Office can indicate precisely how many specific works were copyrighted, although collectors have identified thirteen pieces of art to date. The firm never corrected the misspelled last name of Bessie Pease Gutmann (printed "Gutman") which appeared on thousands of advertising pieces from 1909–1911. Printed in full color, the pictures were simple line drawings filled in with pastels or watercolors, representing original works of the artist that were never issued as art prints. Carrying the titles of "The Defenders," "Allow Me," "A Little Breezy," "Which Hand?," "New Arrivals," "Easter Boy," "First Aid" (Fig. 2-6), "Vacation," "His First Attempt," "Who's Afraid?," "Tired Out" (Fig. 2-7), and "The Runaways" (Fig. 2-8), they were used as illustrations on advertising post cards, ink blotters, paper fans, salesman call back cards. They were also issued to merchants on postcard-size heavy stock with just the image and punchout hanging hole. The reverse side was blank for the imprinting of advertising messages. The images on the calendar postcards were in bright lithographic colors, had messages printed on front or back, a hanging hole at the top, and a single month printed so that the merchant would receive twelve different images each year.

Swift & Company of Chicago published a four-panel calendar each year to

FIG. 2-5 "Bubbles" No.
714 (1923). (Author's col-
lection)

From Corn Flakes to Pajamas—Commercial Art

FIG. 2–6 "First Aid"
No. 126 (1909), Brown &
Bigelow, St. Paul, Minn.
(Author's collection)

use as an ordering incentive for their retailers. Retail stores handling Swift products gave the calendars as premiums to their customers. Over the years, Swift had commissioned such artists as Howard Chandler Christy, Philip Boileau, C. Allan Gilbert, Neysa McMein, and others to prepare original art for their calendars. In 1913, Bessie Pease Gutmann was commissioned by the packing company to prepare their 1915 calendar which was entitled "Swift's Premium Nature Study Calendar for 1915." This was an opportunity coveted by illustrators of the time and she made the most of it. She developed four panels with a subject title from nature and depicted the four seasons: "Animals" (January–March), "Flowers" (April–June), "Butterflies" (July–September), and "Birds" (October–December). Her choice of medium was charcoal and watercolor. Each panel had its own composition and relied on three human figures, a mother and two small children, engaged in activities associated with the seasons (Figs. 2-9 and 2-10). These charming and delightful brightly colored works were reproduced in full color devoid of advertising matter. Swift & Company was obviously pleased with the results for they advertised the 1915 calendar as "The handsomest and most interesting of the famous series of Swift's Premium Calendars. . ."[45] (Fig. 2-11).

FIG. 2-7 "Tired Out"
No. MY 6149 (1909),
Brown & Bigelow, St.
Paul, Minnesota. (Collection of Eleanor and William Popelka)

In-House Calendars

For a period of twenty-eight years (1928–1956) Gutmann & Gutmann prepared calendars under contractual agreements with Glendale Knitting Corporation-The Perry Knitting Company, Perry, New York, and The Hawkeye Pearl Button Company, Muscutine, Iowa. These companies sent out calendars as customer premiums and for customer advertising (Fig. 2-12). The calendars were assembled in the offices of Gutmann & Gutmann and the images were the regular copyrighted prints of Bessie Pease Gutmann subjects, mounted on heavyweight, pastel-colored construction paper. They were imprinted with the contracting firm's name, came with a calendar pad attached, and were tied with a colorful silk bow hanging ribbon. The calendar measured $14\frac{1}{2}'' \times 21\frac{1}{2}''$.

FIG. 2–8 "The Runaways" (paper fan) No. F6143, Brown & Bigelow, St. Paul, Minnesota. (Author's collection)

Other Calendars

The Robert Chapman Company of New York produced 11″ × 14″ calendars in 1911 and 1912 which featured the art of Bessie Pease Gutmann. The art had originally appeared as plates in books published by Hurst and Company but remained under the copyright of the Robert Chapman Company. The book plates were enlarged and reproduced on heavy coated paper stock with a punch hole at the top for hanging and a calendar pad attached. The calendars were then marketed in card and stationery stores.

Advertising Tin

A commission in 1910 from The Wells and Richardson Company, Burlington, Vermont, resulted in the production of one of Bessie Pease Gutmann's most rare and delightful pieces of art. The Company, well-known for its exceptional point-of-sale advertising, contracted for artwork that could be used with their Diamond Dye product. This resulted in a charming example of the artist's work showing a little girl busily dyeing her dolly's frocks (one dolly in a state of undress and the other four patiently awaiting their turn). Measuring only 17″ × 11″ and self-contained with hanging cord, the sign is aptly inscribed "A Busy Day in Dollville" (Fig. 2-13).

The reverse side of this sign is a treasure trove of information, and after a short discourse on Mrs. Gutmann it states: "The painting has been most skillfully reproduced by the lithographic experts of the American Art Works

FIGS. 2–9 & 2–10 Four
panel Swift and Company
calendar (1915). (Collec-
tion of Susan and Warren
Wissemann)

From Corn Flakes to Pajamas—Commercial Art

FIG. 2–12 1940 premium calendar of the Hawkeye Button Company of Muscatine, Iowa, featuring the Bessie Pease Gutmann print, "Mine" No. 798 (July 29, 1939). (Author's collection)

Within the image: DIAMOND·DYES ARE THE BEST · BESSIE PEASE GUTMANN · "A Busy Day in Dollville" · COPYRIGHT 1911, WELLS & RICHARDSON COMPANY.

FIG. 2–13 "A Busy Day in Dollville," the only known advertising hanging tin created by Bessie Pease Gutmann. Issued and copyrighted by The Wells and Richardson Company of Burlington, Vermont for their Diamond Dyes product in 1911. This 17″ × 11″ piece is considered one of the rarest items in Gutmann collections. (Author's collection)

in their unique plant on Coshocton, Ohio. It was printed on specially prepared steel by them, by means of the off-set process which is attracting so much attention among the most progressive of the present day high grade printers and lithographers." Even more quaint in context is the next line: "Duplicates of this Art Work at $1.00 Each." The inference is that prints were issued. However, other than the tin itself, no prints have been reported. This 1911 copyrighted advertising tin is highly sought after by collectors and auction prices for the tin have been known to exceed $1,000.

A True Delineator of Child Life— Magazine/Periodical Illustration

3 🖋

CONSIDERING THE SHORT SPAN of time that Bessie Pease Gutmann labored in the field of magazine cover and article illustrating, it is astounding to realize that she created nearly a hundred original works in just two phases of illustrative art. Of course, the time was right, for the early part of the new century had brought major changes in the graphic art industry. More magazines and periodicals were available and people were reading more. Already occupied with regular advertisement work, Gutmann readily accepted other offers in the broad field of illustrating. A review of her work in this field of art indicated that she had a prodigious talent for illustration, and a fuller appreciation of her versatility and range of artistry may be seen by studying her magazine illustrating period, however short.

The Investigative Artist
Preparing original illustrations to be used in advertising in her early years was certainly necessary work for the young Miss Pease, and although rewarding in a small way, it was undoubtedly not at all satisfying to a budding artist. A natural gravitation to illustrating poetry and articles in the many magazines of the times was to be expected. She spent a total of only three years in such work but the opportunities afforded her were many. In addition to the privilege of her signature appearing on illustrations, she was required to research topics in order to accurately depict illustrating scenes. The challenges of investigative artistry were of considerable interest to her.

A great many social reforms were taking place in New York City at the time that Miss Pease was living there and the opportunities to gain experience as an investigative artist were many. Two articles, both of which appeared in *Pearson's,* required her to do sketching work at Bellevue Hospital, the Central Office of the New York Police Department, and Randall's Island. She also came in contact with representatives from the Guild of the Infant Savior, State Charities Association, and the Society for the Improvement of the Condition of the Poor. The two articles that she illustrated were by investigative journalists Annette Austin and Robert Sloss who authored "The Foundlings of New York City" (February 1906) and (Fig. 3-1) "Lost Children of Greater New York" (October 1905). Her hard-

lined pen and ink and charcoal pencil lines were well-suited for this type of black and white illustrating, however, she would soon abandon this technique. Her illustrations for these two stories were sensitive, exacting, and quite reminiscent of her realistic work of charcoal pencil and ink wash at the Art Students League. She had opportunities to do multi-images which represented many ethnic groups and all racial groups, and, contrary to the habits of the time, she never resorted to caricatures in her subjects.

The 1905 story, "Cupid and the First Reader," by Amanda Mathews was a delightful tale concerning Mexican-Americans learning the English language and young love. In her illustrations for this story Miss Pease was required to depict people of another culture in believable situations and did this quite well (Fig. 3-2).

Poetry Illustration
In the few selections of poetry that she illustrated in 1905–1906, a poem by W. H. G. Wyndham Martyn, *When the Toys Wake Up,* provided her with the chance to present to the public those images that would become identified

FIG. 3-2 Unpublished illustration. (From *Cupid and the First Reader* by Amanda Mathews. New York: *Pearson's Magazine,* December 1905). Four illustrations were originally prepared but three were used. (Collection of Alice Gutmann Smith)

with her artistry. On one full page of poetry she was able to illustrate a child asleep in a crib, a pull-toy horse, a pull-toy ram, a mouse, a Teddy bear, a puppy dog, boy and girl dolls, a soldier, a clown, and a baby doll (Fig. 3-3). The single line illustrations were characteristic of so many of her contemporaries that it was difficult to attribute the work to a particular artist. However, the ability of Bessie Pease Gutmann to give her images human qualities and to select situations which all people could relate to, served to set her work apart from the others. This was recognizable in some of the other poems that she illustrated: *Smiling, Slip Asleep* (*St. Nicholas,* October 1904), *Brave Annabel Lou* (*St. Nicholas,* December 1905), (Fig. 3-4) *On The Hillside* (*St. Nicholas,* August 1905), and *The Fairies and the Babies,* (*Pearson's,* April 1906).

Cover Art

Bessie Pease Gutmann created twenty-two covers during the period 1906–1922 for such popular magazines as *Pictorial Review, McCall's, Woman's Home Companion, Pearson's, The Circle and Success,* and the monthly magazine section of *The Chicago Sunday Tribune, The Boston Sunday Globe,* and *The Washington Post.* Moving from book, short story, and poetry illustrations to magazine and tabloid cover work she achieved almost instant success and became one of the most popular artists of the period. Cover work gave her the opportunity to bring Gutmann babies to the attention of

WHEN THE TOYS WAKE UP

When father and mother are fast asleep,
 And there isn't a noise in the house,
Except the sound of the wind outside
 Or the squeak of some little gray mouse,
There's a sudden stir in the Baby's room,
 And it's lit with a wonderful light,
And wouldn't the nurse be surprised if she saw
 How the Toys all change in the night!

The little brown horse with the broken leg
 Who is sleeping by Baby's side,
Grows well again, and prances 'round
 For the baby to take a ride,
And the Bow-wow, too, who's lost ears and tail,
 He grows a most wonderful coat,
And you never saw such magnificent horns
 As are grown by Billy the Goat.

And then in a twinkle the Soldierman
 Steps down from his round wooden stand,
And he and the doll with pretty blue eyes
 Start off for the Fairies' Land.
There are other Babies to meet of course,
 And other Geegees to ride on;
And though they go fast and jump over high walls
 The Babies don't have to be tied on.

And when they are tired, they ride back to bed;
 And the Soldier mounts guard once more;
And the Geegee nestles by Baby's side,
 And the Bow-wow stands by the door.
And no one knows when the morning comes
 What keeps Baby so well and bright,
It's because of the wonderful things he did
 When he played with the Toys by night.

W. H. G. WYNDHAM MARTYN

large numbers of readers who began to recognize her renderings as special events. No artist of the time achieved such reader popularity as she did.

Her first cover assignment was a Christmas theme cover for the December 1906 issue of *Pearson's Magazine.* The editor of *Pearson's* had witnessed some of her early work in the magazine when she illustrated some poetry and short stories (Fig. 3-5). *Pearson's,* in heavy competition with *McCall's Magazine,* had developed a format that appealed to general readership but also elected to have its staff writers perform investigative work. Gutmann was one of many young artists that publishers were scrambling for in order

FIG. 3–2 Unpublished illustration. (From *Cupid and the First Reader* by Amanda Mathews. New York: *Pearson's Magazine*, December 1905). Four illustrations were originally prepared but three were used. (Collection of Alice Gutmann Smith)

with her artistry. On one full page of poetry she was able to illustrate a child asleep in a crib, a pull-toy horse, a pull-toy ram, a mouse, a Teddy bear, a puppy dog, boy and girl dolls, a soldier, a clown, and a baby doll (Fig. 3-3). The single line illustrations were characteristic of so many of her contemporaries that it was difficult to attribute the work to a particular artist. However, the ability of Bessie Pease Gutmann to give her images human qualities and to select situations which all people could relate to, served to set her work apart from the others. This was recognizable in some of the other poems that she illustrated: *Smiling, Slip Asleep* (*St. Nicholas*, October 1904), *Brave Annabel Lou* (*St. Nicholas*, December 1905), (Fig. 3-4) *On The Hillside* (*St. Nicholas*, August 1905), and *The Fairies and the Babies*, (*Pearson's*, April 1906).

Cover Art

Bessie Pease Gutmann created twenty-two covers during the period 1906–1922 for such popular magazines as *Pictorial Review, McCall's, Woman's Home Companion, Pearson's, The Circle and Success*, and the monthly magazine section of *The Chicago Sunday Tribune, The Boston Sunday Globe*, and *The Washington Post*. Moving from book, short story, and poetry illustrations to magazine and tabloid cover work she achieved almost instant success and became one of the most popular artists of the period. Cover work gave her the opportunity to bring Gutmann babies to the attention of

FIG. 3–3 Illustration from "When the Toys Wake Up" by W.H.G. Wyndham Martyn. New York: *Pearson's Magazine*, September 1906, p. 272.

WHEN THE TOYS WAKE UP

When father and mother are fast asleep,
 And there isn't a noise in the house,
Except the sound of the wind outside
 Or the squeak of some little gray mouse,
There's a sudden stir in the Baby's room,
 And it's lit with a wonderful light,
And wouldn't the nurse be surprised if she saw
 How the Toys all change in the night!

The little brown horse with the broken leg
 Who is sleeping by Baby's side,
Grows well again, and prances 'round
 For the baby to take a ride,
And the Bow-wow, too, who's lost ears and tail,
 He grows a most wonderful coat,
And you never saw such magnificent horns
 As are grown by Billy the Goat.

And then in a twinkle the Soldierman
 Steps down from his round wooden stand,
And he and the doll with pretty blue eyes
 Start off for the Fairies' Land,
There are other Babies to meet of course,
 And other Geegees to ride on;
And though they go fast and jump over high walls
 The Babies don't have to be tied on.

And when they are tired, they ride back to bed;
 And the Soldier mounts guard once more;
And the Geegee nestles by Baby's side,
 And the Bow-wow stands by the door.
And no one knows when the morning comes
 What keeps Baby so well and bright,
It's because of the wonderful things he did
 When he played with the Toys by night.

W. H. G. WYNDHAM MARTYN

large numbers of readers who began to recognize her renderings as special events. No artist of the time achieved such reader popularity as she did.

Her first cover assignment was a Christmas theme cover for the December 1906 issue of *Pearson's Magazine*. The editor of *Pearson's* had witnessed some of her early work in the magazine when she illustrated some poetry and short stories (Fig. 3-5). *Pearson's*, in heavy competition with *McCall's Magazine*, had developed a format that appealed to general readership but also elected to have its staff writers perform investigative work. Gutmann was one of many young artists that publishers were scrambling for in order

FIG. 3–4 "On The Hillside" (illustration used for a poem of the same name by F.S. Gardiner. New York: *St. Nicholas Magazine,* August 1905, p. 881).

to meet demands for illustrations to accompany romances, mysteries, adventure stories, profiles, and how-to articles that filled magazine pages. She selected her stylized young girl with an armful of toys and a Teddy bear was included in the lower portion of the picture for good luck. The little girl with large bows in her hair and black patent leather shoes was typical early Gutmann and was the last of her simplistic, single-line, bright colored images. This was her first public work signed with her married name (she dropped her balloon-type signature for a block Roman letter style which she also dropped shortly afterward), and her first major work to appear in color.

After the 1906 cover for *Pearson's,* her style and choice of subjects began to show artistic maturity, for only rarely would her single line illustrations or her little girl images with immense hair ribbons and ruffles be seen. Using broad sweeping lines with her charcoal pencil or stick, she now developed her skills in the application of color, became a master of mixed media techniques, and worked at the use of a variety of color sources to obtain effects that rendered her images inescapably human.

This is clearly found in her next major cover assignment for *Woman's Home Companion* which appeared in August 1907. For this cover she chose to illustrate a young boy blowing bubbles and demonstrated how a simple subject, highlighted with water color and pastels, created an effect that was most pleasing to the readers of the magazine. The editor of *Woman's Home Companion* immediately designated "Bubbles" as the title for the work and commented, "Many readers will want to frame the charming cover of this issue, which surely ranks high among the famous 'baby covers' of the *Woman's Home Companion.* The original painting by Bessie Pease Gutmann, of which the cover is a faithful reproduction, was one of the most highly regarded designs submitted for the $1,500 prize. Mrs. Gutmann's work is especially popular in exclusive art shops, where her prints, much smaller than this cover, sell for $1.50 or more . . Copies of the cover will be sent to any address for ten cents each, postpaid."[46]

Pictorial Review was the one magazine that cover artists sought for their art

because of its large format and fine color reproduction. This opportunity to showcase one's work was utilized by Gutmann twelve times in a few brief years. It was not necessary for her to work on commissions because her work was so readily acceptable. It was only necessary to submit work and it would be reproduced. She was approached many times with long term contracts for cover features but she graciously declined. She had witnessed how some of her contemporaries, with term contracts, were obliged to produce specific work under rigid time constraints and this was unacceptable to her. She preferred to work with the privilege to self-determine her work hours, deadlines, and choice of subjects. The fact that she painted so few for *Pictorial Review* is understandable, but what is remarkable is that most of the works used as magazine covers were painted especially for that purpose and were not converted into fine art prints until *after* they appeared as cover illustrations.

The editors of *Pictorial Review* titled their March 1913 cover "The Crying Baby" and commented, "Every mother knows exactly what is the matter with 'The Crying Baby' on our cover this month. He is not sick, nor is he lonesome. He is just plain mad. But you have to love the little tyrant just the same—he is so human. The original painting is the work of Bessie Pease Gutmann . . . and this tiny bit of furious humanity represents perhaps her masterpiece. It is the cover hit not only of this season but of many seasons past, and we dare almost to predict of seasons to come."[47] Gutmann & Gutmann retained the copyright on the work and issued the same image under the title "Our Alarm Clock" (1913) as an art print (Fig. 3-6).

Although she shunned competitive exhibitions and belonged to no major art-related society, it was her cover work that brought her awards and recognitions both in the United States and Europe. She received the "Artist of the Year Award" given by *Pictorial Review* magazine in 1915 after her work was in competition with, according to the editor of *Pictorial Review,* "twelve of the greatest cover artists of the world." Each of the artists were engaged to do a cover for a particular month during the 1914 year and five million readers were requested to vote on which artist produced the finest painting. According to *Pictorial Review's* editorial board they were "more than pleased by the unprecedented interest on the part of . . . readers as shown by the many thousands of votes received. It was unquestionably the most successful voted contest of its kind ever held by any magazine."[48]

When the votes were counted Bessie Pease Gutmann's painting of a little boy and his puppy dog, which had appeared on the cover of the March 1914 issue of *Pictorial Review,* won first prize with a landslide number of votes (Fig. 3-7). Five hundred dollars went to Mrs. Gutmann, and covers by Philip Boileau, Clarence F. Underwood, and C. Allan Gilbert were awarded second, third, and fourth place prizes respectively. Other contestants whose covers appeared on issues of *Pictorial Review* in 1914 but were unsuccessful in securing a prize were Franklin Booth, Jame Montgomery Flagg, Rose O'Neill, R. Cory Kilvert, Penrhyn Stanlaws, A. B. Wenzell, George Gibbs, and Grace G. Drayton. These were representative of some of the finest illustrators in the history of illustration. In making the award the *Review* editor referred to Bessie Pease Gutmann as "one of the most successful painters of children of the present day."[49] Her charming subject of the boy

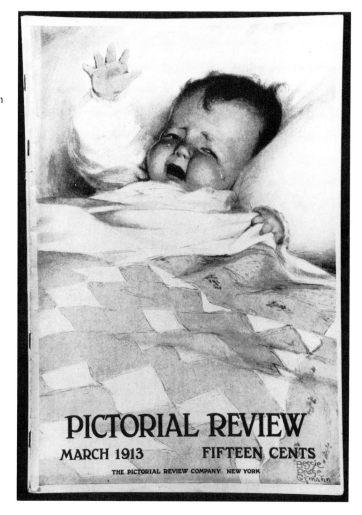

and the puppy dog was later issued as a fine art print (Fig. 3-8) in 1918 with the title of the American Doughboy's song, "Pack Up Your Troubles In Your Old Kit Bag and Smile, Smile, Smile" (1918).

In March 1917 one of the most charming of her works appeared on the cover of *Pictorial Review*. The untitled figure of a chubby-cheeked, dark-haired little girl shown blowing an enormous soap bubble from her upside down clay pipe utilized the entire 11″ × 16″ cover. This painting represented Bessie Pease Gutmann at her best. The use of blue pastels and charcoal overlays for shading created a mood of expectation. It is small wonder that the Gutmann & Gutmann firm issued the same picture as an art print in 1922 and titled it "An Anxious Moment" (Fig. 3-9).

The Metropolitan Life Insurance Company of New York offered a handsome commission to Bessie Pease Gutmann for a work that could be used on the first issue of their house organ, *The Metropolitan*, for the new year. She chose what she considered an appropriate subject and created an artwork titled "Sweet Sixteen." This particular title had previously been

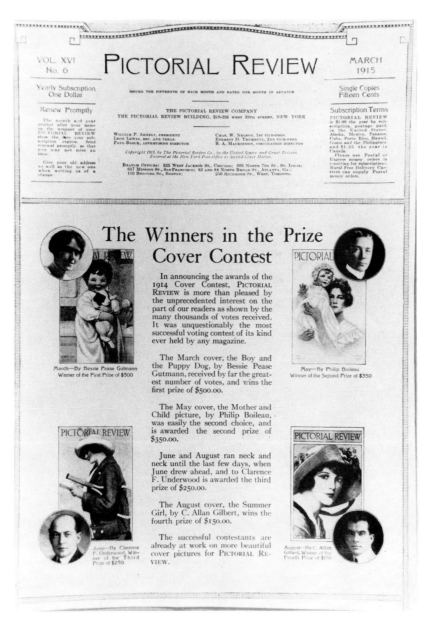

FIG. 3-7 Editor's page of *Pictorial Review,* March 1915. (Author's collection)

used for a 1909 (No. 154) print but the illustrations were completely different. For this cover she showed a lovely teenager of the period seated in a corner chair and looking out at the world in sweet innocence (Fig. 3-10). This pastel work was outlined with muted shading and was representative of the artist's concept of young adults. It appeared as the January 1911 cover of the magazine. It was to prove to be a very popular work by Gutmann and, in addition to its appearance as a magazine cover, the same image was released as a postcard in 1911 as part of the Young Women series under still another title, "Rosebuds."

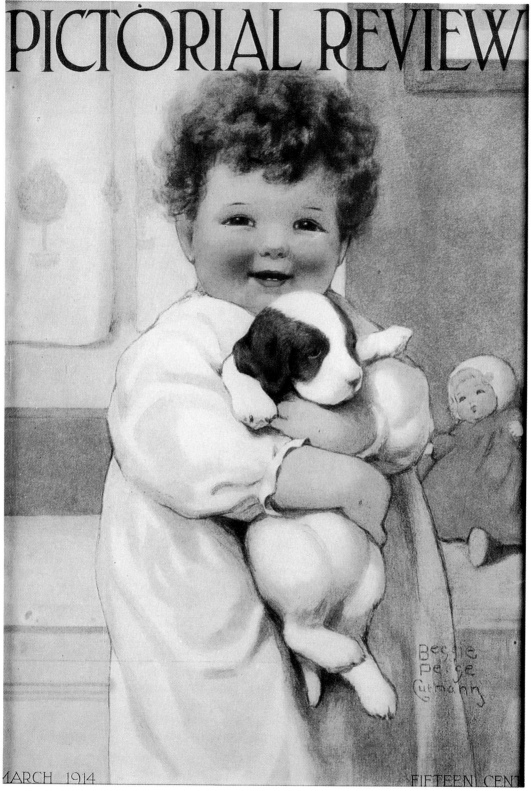

PICTORIAL REVIEW

MARCH 1914

FIFTEEN CENT

FIG. 3–8 "Smile, Smile, Smile" cover for *Pictorial Review*, March 1914. (Collection of Susan and Warren Wissemann)

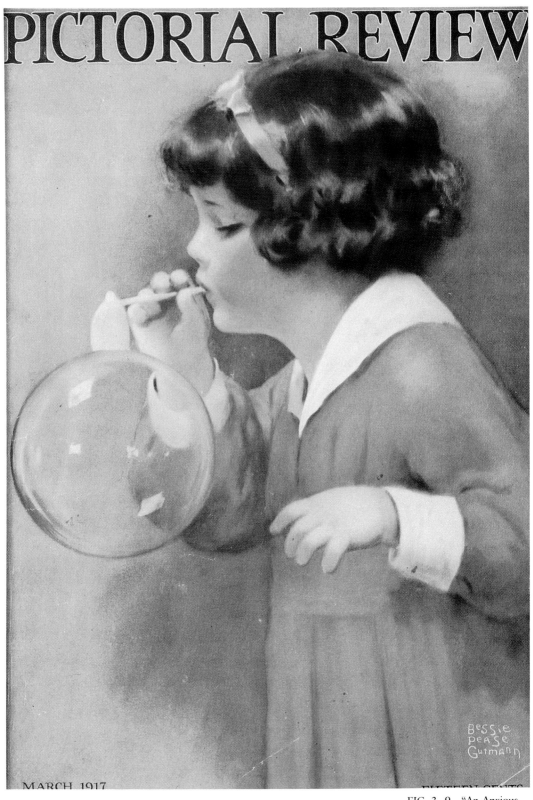

PICTORIAL REVIEW

MARCH 1917

Bessie
Pease
Gutmann

FIG. 3-9 "An Anxious
Moment" cover for
Pictorial Review, September
1917. Issued as fine art
print No. 711, June 3,
1922. (Collection of Susan
and Warren Wissemann)

Stories for Little Tots— Illustrated Books

4 🪶

BESSIE PEASE GUTMANN achieved considerable success and recognition for her illustrations, but it may not have been her original intention to have her art career take such a course. She drifted into illustrating books as the result of an interesting circumstance. She began preparing twenty-two black and white drawings in 1904 to be used as illustrations for a serial story that was to appear in *St. Nicholas Magazine.* The serial story, "From Sioux to Susan," authored by Agnes McClelland Daulton, ran in six parts from 1904 to 1905. It was so popular that The Century Company, the publisher of *St. Nicholas,* released it as a 342-page hardcover book in 1909. Poet Edwin Markham recommended the book, commenting that it contained "brave little lessons of life and love . . . it is a sweet and wholesome story of a very dear family of brothers and sisters. The pictures, by Bessie Collins Pease, are charming."[50] The unusually large number of illustrations prepared by Miss Pease for this book, about a teenage school girl, showed a delightful sprightliness. Although they were all in black and white, she utilized shading as a substitute for color and created a half-tone effect which gave perspective and motion to her subjects.

The first books that she illustrated were under a short term contract with the Dodge Publishing Company of New York whose editors were impressed with the originality of Miss Pease's work and the quality of her craftmanship. In 1905 she illustrated the first of three books that she was to do for Writer-Poet Edmund Vance Cooke. *Chronicles of the Little Tot* and its sequel, *Told to the Little Tot,* were so well-received that excerpts from the books appeared in *Woman's Home Companion, The Youth Companion, The Delineator, The Golden Age,* and were syndicated to various newspapers in the United States by the Newspaper Enterprise Association.

In the first two editions of *Chronicles of the Little Tot,* Clyde O. Deland is credited as the book's illustrator despite the fact that the little-known Bessie Collins Pease provided six of the book's eight illustrations. It wasn't until the third edition printing in July of 1906 that she was properly credited on the title page. In the sequel, *Told to the Little Tot* (1906), Bessie Collins Pease was listed as the illustrator. She prepared nine full-page color illustrations and many black and white illustrations, all signed with her usual "balloon-

type" signature. The illustrations used in both books were full-bodied images with complete decorative backgrounds, the chief mediums being watercolor and pastels over charcoal. These pictures established her as an artist capable of working with mixed media and a variety of subjects.

She was immediately assigned the task of creating nineteen full color illustrations for Edmund Vance Cooke's next book, *The Biography of Our Baby* (1906). This time she dropped her full maiden name signature and used the initials "B.C.P.," signed in her balloon style. When her first child, Alice, was born on October 24, 1907, she started making handwritten comments in a copy of this book. The three books were so popular that the Dodge Publishing Company issued full-size color prints of some of her illustrations that appeared in the books. These prints were generally issued with titles different than what had appeared in the books so that they'd be more marketable (Fig. 4-1).

Her illustrations for the 1905 book published by Dodge, *A Child's Garden of Verses*, by Robert Louis Stevenson, were delightfully done and pleased the publisher. Other artists of the time were also illustrating the same classic and the competition among publishers was fierce. Scribner's Children Classic released Jessie Willcox Smith's illustrated version in the same year and others soon followed. Bessie Collins Pease created a remarkable number of full-color plates for the book, twenty-four in all, plus many black and white illustrations. Dodge's version, featuring her full-bodied, happy children, went into several printings.

She was given her first major book commission by the Dodge editors in 1907 when she was asked to prepare the illustrations for Lewis Carroll's *Alice's Adventures in Wonderland*. Her version would follow on the heels of illustrator Fanny Young Cory's, whose book was issued in 1902. Ten color plates were needed and Gutmann prepared herself in a very unique way. She secured a small, early version of the story (with the original illustrations by John Tenniel) published by the Henry Altemus Company of Philadelphia. "So as not to be influenced by the original artwork, she covered each of the black and white illustrations with opaque paper."[51] A year after the book was published she described her feelings thusly: ". . . there are few children and fewer grown-ups who have not read Alice and her adventures, and so you will probably think me unique when I tell you that up to the day that I received the commission to illustrate a new edition of Alice, I not only had never read her experiences, but I never held a copy of the book in my hands. I felt very ashamed of myself, but at once set to work and read it over and over again until I could have recited all the adventures in chronological order. Then I started work and made ten full-page illustrations and fifteen smaller pictures. The work was a very great pleasure to me, and I was glad, you may be sure, to learn afterwards that I had caught the fancy of the public with my idea of Alice and her wonderful experiences."[52]

Her charming images of Alice and her companions, created almost nine decades ago, continue to delight collectors and gather admirers (Fig. 4-2). The book was also published in Great Britain by George G. Harrap and Company Ltd. (third edition, 1919) and J. Cookes & Company Ltd. (1933). The latter contained six full-page color illustrations with the decorative borders around the illustrations credited to G.P. Michlewright.

FIG. 4-1 "The First Lesson." (From *The Biography of Our Baby* by Edmund Vance Cooke. New York: Dodge Publishing Company, 1906, p. 4). (Author's collection)

Bessie Pease Gutmann's work on this particular book made such an impression on her that she named her first daughter "Alice." In 1909 the Dodge Company published the sequel *Through The Looking Glass: And What Alice Found There*. It contained eight full-page color illustrations by Bessie Pease Gutmann.

It was quite common in the early days of book illustrating for brokers to contract with a new artist for a certain number of paintings which could be

used in published story books for children. The Robert Chapman Company of New York was just such a broker, and sometime in 1908 they contracted with Bessie Pease Gutmann to produce several general artworks involving young children at play. She sold the works and the copyrights to the Chapman Company who in turn offered them to various book publishers. Hurst and Company in New York published inexpensive children's books and used her and other artists' illustrations. Gutmann's illustrations appeared in at least ten Hurst books during 1910–1912 and, since only four different illustrations have been identified, there are many duplications of illustrations.

In 1906 she agreed to prepare illustrations (Fig. 4-3) for Edith Dunham's story, *The Diary of a Mouse*. She was in the midst of her wedding plans when she set out to create the pictures for a book whose central characters were to be mice. Her twenty-five black and orange shaded illustrations (twenty-three signed with her married name and two with the usual balloon-signature of her maiden name) told the story of a family of mice. Her keen sense of humor is evident as she gives adult-like demeanor to her tiny subjects.

FIG. 4-3 "Moved into High School today— September 6." (From *Diary of a Mouse* by Edith Dunham. New York: Dodge Publishing Company, 1907). (Author's collection)

Although the financial reward was not great for artists who prepared paintings to be used as book illustrations, the activity did provide an abundance of experience, as well as recognition for artistry. Bessie Pease Gutmann's book illustrating period covered just five years. During that time it is estimated that she created over one hundred individual illustrations, many of which were never issued in fine art print form.

5 Into a Gentle World— Fine Art Prints

BESSIE PEASE GUTMANN is known primarily as an artist whose renderings of real, unaffected, unidealized children were turned into fine art prints, and it was these images of childhood through which she attained her success. She loved children with all her being, so it was quite natural for her to draw them, and of course they were highly marketable. But her artistic energies were not wholly confined to expressing "Gutmann babies." In reviewing her work which spanned almost half a century, it is discovered that her talents were as diverse as her subjects. Further, the works show an amazing attention to detail and expression which few artists have come close to equaling. It is small wonder then that recognition of her workmanship, choice of appealing subjects, and the distinct quality she manifested brought a worldwide demand for her art.

Perhaps it is in her own pencil and charcoal drawings done at the ages of seven (Fig. 5-1), thirteen (Fig. 5-2), and sixteen that we begin to recognize the true artist—the one who loved to draw animals, children at play, and self-portraits. Her ink washes and charcoal pencil renderings, done as part of her classwork at the Art Students League in New York, give a deeper insight into the art-mind of this complex person. They reveal the influence of her former instructors; the realism of Robret Henri, the effect of the single line from Alice Barber Stephens, and the tenets of composition from her mentor Kenyon Cox, in whose Life Class she demonstrated considerable maturity, discipline, and superior charcoal work. This work also showed another characteristic of hers, namely, a refusal to use caricature renderings to picture ethnic and racial groups. She signed in pencil all of her work in Cox's classes as "Bessie Collins Pease 1899" (Fig. 5-3).

Times were changing at the turn of the century and two occurrences had an immediate impact on Bessie Collins Pease. The first of these was the technique of applying watercolor over charcoal pencil which she was experimenting with. Watercolors were not considered "respectable" art since it was generally associated with illustration and commercial design, and while it was a popular vehicle for recording the picturesque qualities of the American landscape, it retained secondary status within the hierarchy of the fine arts . . . with the formation of the American Society of Painters in

FIG. 5–1 Pencil sketch of children done at age seven. (Sketchbook #3, courtesy of Alice Gutmann Smith)

FIG. 5–2 Sketch of ram and sheep done at age thirteen. The notation is Gutmann's. (Sketchbook #2, courtesy of Alice Gutmann Smith)

March 1890.
Age 13.

FIG. 5-3 Signed sketch of a woman and child completed by Bessie Collins Pease at the Arts Students League in 1899. (Collection of Mrs. John C. Gutmann, Sr.)

Water Color in 1866 and the annual New York exhibitions it sponsored, watercolor attained the prestige of a major artistic force with artists, critics, and the public. . ."[53] By the turn of the century nearly every important artist in the country was experimenting with the medium and their works revealed a wide variety of subject matter and technical range (Fig. 5-4). The works of that period by John Singer Sargent, Winslow Homer, and Thomas Eakins were prime examples of the new movement which Bessie Collins Pease had entered.

The second event was the advent of better quality printing for both color and black and white. The introduction of coated paper of superior finish, weight and strength made for magnificent cover reproduction. The new

FIG. 5-4 Ink wash study of two young boys playing marbles done by Bessie Collins Pease in her Advanced Illustration class at the Art Students League in 1899. (Collection of Mrs. John C. Gutmann, Sr.)

color process revolutionized the fine art print industry as well as the book publishing business. Fine art prints would continue for several more years to be "finished" by colorists, but the process of single color reproduction was improved dramatically.[54]

The Year was 1907

The time was right for a renaissance in the fine art print field. The new printing presses were producing better quality and richer looking prints and quality control was now becoming a common practice (Figs. 5-5 – 5-9). The work of Bessie Collins Pease as a commercial artist with the firm of Gutmann & Gutmann underwent a complete change when she became the firm's chief artist for its art print business. Shortly afterward she married Hellmuth, the elder of the Gutmann brothers. Their union resulted in a beautiful and true marriage and a business arrangement so successful that shortly after 1906 Gutmann & Gutmann confined its business activities solely to art prints.

Some of the early successes came about when print titles were changed and national events were incorporated into prints. One of these successes, "The New Love" (1907), was the first of several works that featured a Teddy bear. When the wave of (Theodore) Rooseveltism swept through the country, it happened that a few bears were imported from France and shown in toy shops in New York. The quickwitted Americans immediately christened them "Teddy" bears and their popularity increased to an alarming extent. It was not just children who fell victims to the charms of "Teddy" but adults as well. Ladies were frequently seen driving down Fifth Avenue with a Teddy bear sitting beside them. Bessie Pease Gutmann immediately conceived the idea to use the Teddy bear in some of her pictures, and she painted a series called "Rooseveltisms," the first of the series being "The New Love".

"Delighted" (also titled "The Happy Hunter") and "The Intruder" were
also done that year (Figs. 5-10, 5-11, and 5-12).

She described how the idea for the "Rooseveltisms" came about thusly:
"Sometimes I have taken to making pictures of children when asleep—the
only time when they may really be said to rest, and it is a curious coincidence
that one of my most popular pictures shows a child fast asleep hugging a
Teddy bear. Just about the time when Teddy bears began to be all the rage, I
happened to have one of my little nieces staying with me. Someone gave her
a very nice Teddy and the child was delighted. Her doll began to be
neglected. She would pet her older friend at intervals but would soon return
to the Teddy bear.

"One hot evening I peeped in at the nursery. She was wrapped in a
profound slumber, Teddy and the doll beside her. But while one hand
lovingly clasped Teddy, the doll was again neglected. The title "The New

Copyright, 1905, by Gutmann & Gutmann, N. Y.

FIG. 5–6 "Young America 1" (no assigned number) issued as a series of four in the 6″ × 6″ size, April 7, 1905. (Collection of Mrs. John C. Gutmann, Sr.)

"Under the Mistletoe"

FIG. 5–7 "Under the Mistletoe," copyrighted by the Dodge Publishing Company, 1904. (Author's collection)

FIG. 5-8 "Not His Match" No. 102, printer's proof. Issued by Gutmann & Gutmann in the 12" × 17" size on December 20, 1905. Reissued in the 9" × 12" size on December 24, 1907. (Author's collection)

Love" instantly suggested itself. I ran for my book, and while the child slept I made a drawing, which I afterwards elaborated a little, though not much. The picture is one that I am very fond of myself, and I am therefore the more glad that the public seem to appreciate it also, for I understand that it is to be seen in almost every country in the world."[55] She used the same idea thirty-two years later when she painted a beautiful golden-haired child asleep and clutching his beloved Teddy bear with his pudgy left hand, which she entitled "Happy Dreams" (1939).

She began, after marriage, to work almost solely on the preparation of artworks that would be reproduced for the art print trade. She used just about every medium known, showing her versatility with her "tools." She did, however, prefer charcoal, pastels, Conte crayon, and watercolor. Her rate of productivity was remarkable and in that first year of art print activity she produced her first paired prints; "Falling Out," originally titled "Twixt Smile And a Tear," and "Making Up," originally titled "Lips That Are For Others."

They were an immediate market success (Fig. 5-13). She described the origin of the two prints to an interviewer who reported it this way: "Mrs. Gutmann has several nieces who figure in many of her pictures, and these children have been photographed dozens—even hundreds— of times when they least suspected that a camera was being focused upon them. All of these photographic studies have materially assisted the artist in her studies of

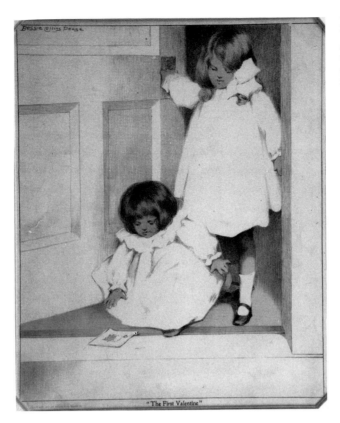

FIG. 5-9 "The First Valentine," copyrighted by the Dodge Publishing Company, 1904. (Collection of Eleanor and William Popelka)

FIG. 5-10 "The New Love" Nos. 107, 300, and 673, January 10, 1907. (Collection of Meredith and Joseph Failla)

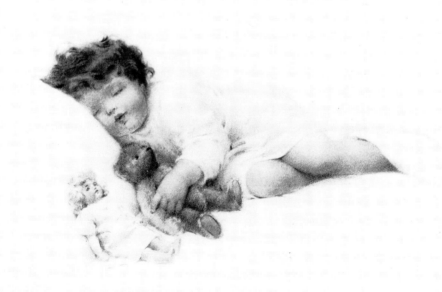

FIG. 5–11 "Delighted" No. 201, April 24, 1907. Also issued under the title of "The Happy Hunter." (Collection of Laurie and Bruce Pierce)

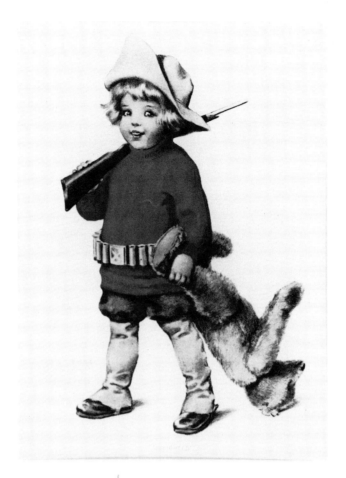

FIG. 5–12 "The In-truder" No. 204, March 20, 1907. (Collection of Susan and Warren Wis-semann)

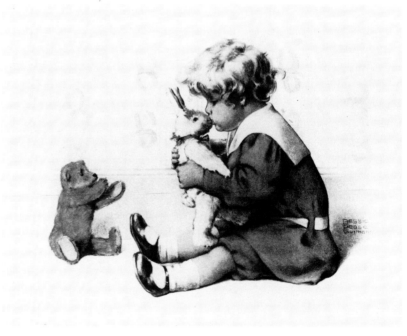

FIG. 5–13 Panel of two matched prints: "Falling Out" No. 101, December 24, 1907 and "Making Up" No. 100, December 9, 1907. (Collection of Susan and Warren Wissemann)

child-life. The little nieces referred to make their appearance in 'Falling Out' and 'Making Up.' 'Although sweet-tempered children, they sometimes quarrel—as all normal children will—and on one occasion, while playing in the garden, they had a terrible falling out, though what the cause of the disagreement was no one ever discovered.' Mrs. Gutmann heard the sound of the wordy argument, and thus was able to study the children from behind a friendly rose bush. The infants told each other some terrible half truths, and then—like good women in miniature—they burst into tears, kissed, and made up again. Afterwards, when all differences were forgotten, the artist gave her small nieces some extra fine candy as a reward for having suggested to her—though quite unknowingly—an incident for a very popular pair of pictures."[56]

Love is Blind

Very early in her career, Bessie Pease Gutmann demonstrated the ability to capture some of the most poignant, delightful, and memorable experiences of children on her drawing surface. This ability to translate emotions, without words, was a characteristic found in all of her works and the public responded with love.

Typical of such works was the first "Love is Blind" (1907). She admits that she had had the idea to do such a work long before she got around to doing it (Fig. 5-14). As Mrs. Gutmann explained it, "I had observed, as I suppose most people have observed, that the oldest and ugliest doll is usually first favorite with its little owner. My smallest niece was no exception to this, and though she had several dolls which were really triumphs of the doll-maker's art, she would turn from them all to hug and kiss a fearfully mangled and dilapidated specimen to which she appeared extraordinarily attached. This doll had lost the top of her head, one leg was gone, a great deal of the 'stuffing' had trickled away (giving the poor thing a terrible emaciated appearance), while her left arm had, during an encounter with the puppy, been torn from its socket. She had several other blemishes, but they were

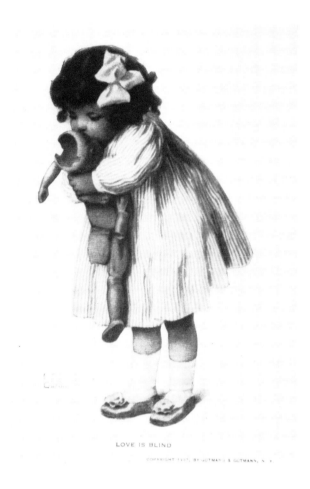

LOVE IS BLIND

COPYRIGHT 1907, BY GUTMANN & GUTMANN, N. Y.

scars of glory in the eyes of the fond mother. Besides, this doll was her first, and she loved it, with an affection only felt by a parent for her youngest born. I made my studies for this picture, but they were all unsatisfactory until finally I saw my young niece in the act of kissing her dilapidated doll, and 'caught' her by a rapid sketch. The picture instantly took the fancy of the child-loving public, and for the reason, I think, that the sentiment was so easily understood."[57]

Years later she would utilize the same idea (Fig. 5-15), updating the clothing of the little girl, and adding some background to her illustration, for another "Love is Blind" (1937), and this time she wrote a little piece of poetry to accompany the work:

> LOVE IS BLIND
> The grown folks say my other dolls
> Are prettier and better dressed.
> They simply cannot understand
> Why I love you the best.
> They say you're downright homely,
> That you're broken and you're old.
> They say you're stuffed with sawdust,
> But I know your heart is gold!

FIG. 5–15 "Love is Blind" No. 795, June 18, 1937. (Used by permission of The Balliol Corp.)

Teddy is Rewarded

Indeed Bessie Pease Gutmann's children were born into a gentle world and it was always a world of sweet innocence. The fact that her models were drawn from real life and that her children also possessed unique spirit and personality were just as much a natural affirmation of her warmth and love for children as it was due to her skill as an artist. Using this skill to combine an animal-friend with a child produced an irresistible picture. This proved to be true when she created a work which was to become part of another successful set of paired prints. Using her daughter Lucille and the neighbor's little collie dog "Teddy" as models, she completed the painting "In Disgrace" (1935) which has been recognized as an art classic (Fig. 5-16).

FIG. 5-16 "In Disgrace"
No. 792, July 3, 1935.
(Used by permission of
The Balliol Corp.)

Into a Gentle World—Fine Art Prints

FIG. 5–17 "The Reward" No. 794, December 3, 1936. (Used by permission of The Balliol Corp.)

FIG. 5–18 "Teddy" the collie dog that was the model for "In Disgrace" and "The Reward." His owners were Mildred and Fred Fulton, close friends of the Gutmanns. Fred Fulton was the owner of a colorist firm.

Words were not required to explain the picture (although Poet M. Leona Harig was hired to write a poem to accompany the picture) and it became popular throughout the world.

The theme, the image, and even the title was not a new one. An English artist in 1876 had painted a similar scene using a large collie dog. Meta M. Grimball, who was one of the Gutmann & Gutmann staff artists, had painted an almost identical scene in 1905. The January 1905 cover of *The Ladies' Home Journal* featured a similar pose of Jessie Willcox Smith's "The First Punishment." Clara M. Burd's "Mischief Loves Company" featured a calico tabby cat in 1912. However, none were to approach the success of "In Disgrace." The heart of the public was captured when they saw the little tot, facing the wall in the corner with her best friend snuggled up against her, looking as sad as any puppy could. It wouldn't do for her to be left standing in the corner, so the public said, and the second print was prepared (Figs. 5-17 and 5-18) and appeared as "The Reward" (1936). This time Bessie Pease Gutmann wrote the poetry which accompanied the print:

> THE REWARD
> My little doggy Rusty's just
> As sweet as he can be
> Not long ago, perhaps you know,
> He shared disgrace with me.
> There's nothing that I wouldn't do
> For one so true and trusty;
> So, now I have an ice cream cone,
> I'm sharing it with Rusty.

"In Disgrace" and "The Reward" graced formal window displays in the Boston store of Jordan Marsh and in New York City's Bloomingdale's, Best & Company, and Abraham & Strauss department stores. In most instances the original art work, on loan from Gutmann & Gutmann, was featured. In 1942, a February window display of the two works was commented on in the trade journal *The Bulletin of the National Dry Goods Association* (April): "Bloomingdale's gave a whole window to a single type picture (perennially popular babies) in February, and reported extraordinarily good results."

A Little Bit of Heaven

The illustration which is reputed to be the record seller of all time, having sold millions of copies since it was first introduced, had the simplest of beginnings. In 1909 Bessie Pease Gutmann's second daughter, Lucille, was born. When Lucille was two months old her mother made a sketch of her while she was sleeping. When she was six months old the sketch was completed and set aside. Seven years later it was finished, copyrighted and presented to the public. "A Little Bit of Heaven" (1916) was a charcoal drawing with light watercolor shadings, without background decorations, showing a sleeping baby. Its simplicity and real-life beauty created a public reaction that the art print establishment was quite unprepared for (Figs. 5-19 and 5-20). Nothing like it had ever been experienced before. Overseas agents, despite World War I, were cabling for thousands of copies. Unfortunately, the Gutmann & Gutmann Company did not record the number of copies printed or sold, but it has been estimated that since its issue several

FIG. 5–19 "A Little Bit of Heaven" No. 650, December 26, 1916. (Used by permission of The Balliol Corp.)

FIG. 5–20 Original sketch of Lucille Gutmann at the age of four weeks. (Collection of Lucille Gutmann Horrocks) (Used by permission of The Balliol Corp.)

millions of copies have been sold and placed in homes all over the world. Not only was it a record seller, but its popularity was used by the print industry "as the barometer of the popularity of similar prints. . ."[58]

The grip this picture had on the public was evidenced by the hundreds of personal letters directed to the artist by individuals who felt compelled to write and thank her for having created such a work of art from which they had derived never-ending pleasure. "A wonderful lady from South Africa wrote to tell [Mother] that she was walking past a store and saw 'A Little Bit of Heaven' displayed and it reminded her immediately of the child that she had recently lost, and she was so thankful that now she would have an appropriate remembrance of her loved one."[59]

Shortly afterward she made a sketch of a neighbor's child, Carolyn Alley (Sisto), while sitting on the sun porch of their home in South Orange. The print was released under the name "Angel's Kin" (1918) but it didn't sell very well. It was suggested that it be paired with "A Little Bit of Heaven" and, since this showed a baby asleep and the other a baby awake, the name of the print be changed to "Awakening" (Fig. 5-21). Thus the paired prints appeared on the market. Within a few short years most homes in the United States had the pair hanging in a suitable place on their walls. So popular were the two prints that trade journals of the day were offering advice as to what type of frames would be suitable to best show them off. One firm suggested that "simple oblong frames, ornamented square or circle all seem to give good results. . ."[60]

Bessie Pease Gutmann brought a timeless quality to her babies which rendered them eternally precious and irresistible to the viewer. Few American homes were without the pair in the 1920s and 1930s and the import market was accounting for large numbers of requests. The fine art print industry was believed to have reached a zenith with the paired prints and few, if any, prints were able to sustain such popularity as did these artistic delights. The sales records have yet to be surpassed. Major department and retail chain stores featured the prints in their art departments for many years.

God Bless Papa and Mamma

Although Gutmann's babies and children had a spiritual quality about them, they were not necessarily heavenly in appearance. She was raised in a family that practiced its Presbyterian teachings in their lives and she attended the Sunday School of the Mount Holly Presbyterian Church, attended church, and was married by the Rev. Charles J. Young of the Presbyterian Church of the Puritans of New York City. It was only natural that she would include in her work some religious themes. In the eight known religious paintings she demonstrated her versatility as an artist and a master of mixed media techniques. In 1911 she painted "Her Legacy," a poignant scene of a young man holding a baby. In a mystical haze behind his chair is seen an angel who is obviously the mother who has died in childbirth. Although it is a sensitive rendering in soft charcoal tones, it was not readily accepted by the public. Her Madonnas, "Madonna" (1913), "Light of Life" (1914), and "Light of Life" (1923), were regarded as quite extraordinary (Fig. 5-22). Utilizing the classic positioning of the Madonna and Child, Bessie Pease Gutmann,

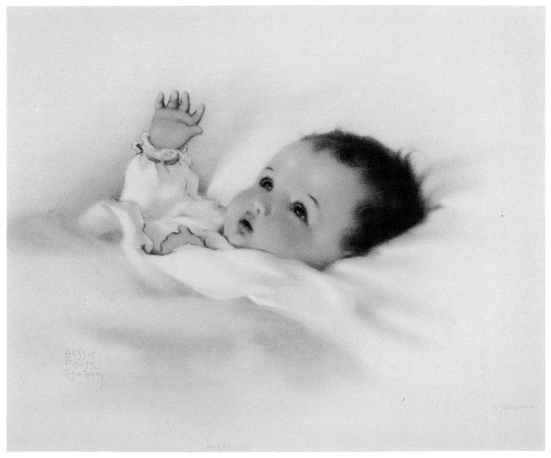

FIG. 5–21 "Awakening" Nos. 259 and 664, November 25, 1918. Originally titled "Angels' Kin" but renamed when paired with "A Little Bit of Heaven." (Used by permission of The Balliol Corp.)

through the use of wash and watercolor over charcoal, was able to achieve tonal shadings on the faces of the two images. The three dimensional effect of light and dark gave the entire work an ethereal quality.

The little hands of a child folded in prayer were used as the focal point of three other works. "Now I Lay Me" (1912) depicts a beautiful blond curly-headed child kneeling with hands folded in her mother's lap (Fig. 5-23). It is a masterpiece of delicate tones and colors achieved through the medium of ink wash, watercolor, and a charcoal base. In this work we find a delightful marriage of subject and atmosphere, for added to the work is a soft detailing of damask drapery, patterned carpet, an upholstered settee with a casual blue pillow, and a beautiful burgundy velvet dress and a chiffon-like stole worn by the mother. The artist succeeds in creating a beautiful and spiritual atmosphere by using motherly love and a child's prayer as her motivators. The two other prints illustrating a child at prayer were "Thank You God" (1951), a blessing for food, and "God Bless Papa and Mamma (1915), a prayer for loved ones, featuring a child, typical of a Bessie Pease Gutmann work, with light and curly hair.

For "Annunciation" (1922) she used oil paint highlighted with pastels and charcoal to achieve an image that is breathtaking (Fig. 5-24). A single

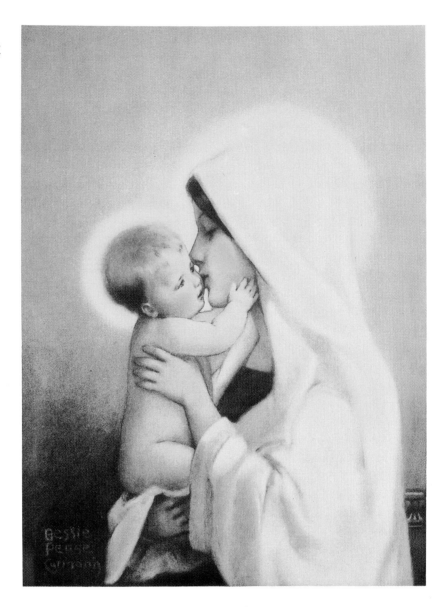

FIG. 5-22 "The Light of Life" No. 633, April 1, 1914. (Collection of Mary and Joseph Connors)

subject is shown looking with obvious rapture at a glow of light emerging from the upper right of the print (diffused by an overlay of charcoal). The right hand of the subject is gently placed on her white robe, resulting in the viewer concentrating on the sculptured hand, the angelic face of the subject, and the heavenly light bathing the subject. The positioning of the hand was of considerable concern to the artist, and her sketch boards show that she experimented with many positions until she found one she considered satisfactory. Unfortunately, these works did not receive the reception from the public as had been expected and after a brief market time they were removed and the inventories destroyed.

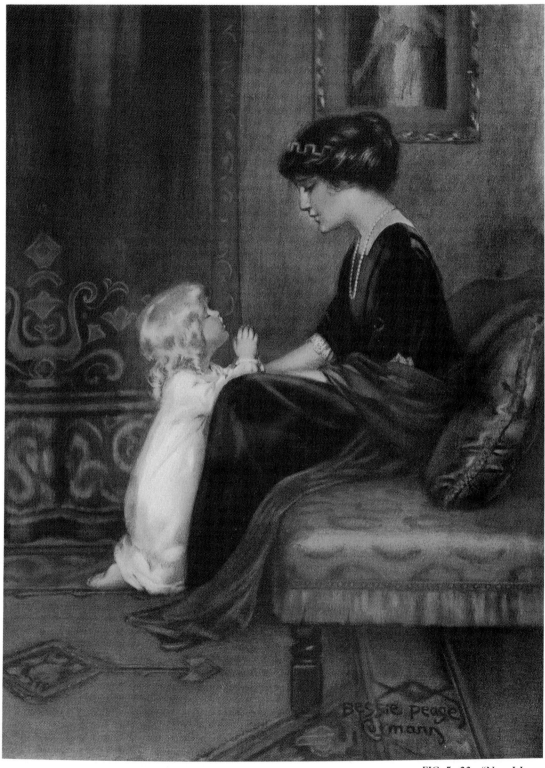

FIG. 5-23 "Now I Lay Me" No. 620, November 7, 12. (Collection of Eleanor and William Popelka)

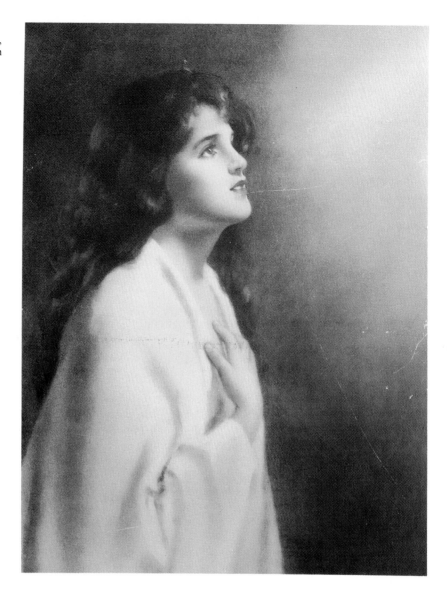

When Daddy Comes Marching Home

It is not known what the inner feelings of Bessie Pease Gutmann were with respect to those times when the United States was engaged in war. It is, however, through her art that we find her emotions being expressed. Nothing of a morbid nor anti-war nature appear on her canvasses of the time. What is found, in the images she used, are the compassions and love of people and the joy of life that characterizes all of her work. Only in one of her World War I themes is there a hint of the rage against the enemy, Germany, as the teutonic war machine ravaged the country of Belgium in the early part of the Great War. In a beautiful, sensitive, and emotional scene, and quite uncharacteristic of her prior work, Mrs. Gutmann shows us a nurse administering to a fallen Belgium soldier as another wounded soldier looks on. This oil on canvas, "A Sunbeam In A Dark Corner" (Fig. 5-25), offered in 1914,

FIG. 5–25 "A Sunbeam in a Dark Corner" No. 638, September 17, 1914. (Collection of Susan and Warren Wissemann)

FIG. 5–26 "When
Daddy Comes Marching
Home" No. 668, January
1, 1919. (Collection of
Christopher T. Wissemann)

Into a Gentle World—Fine Art Prints

commands your attention as your eyes are drawn to the ray of sunshine emanating through a window in a war-torn building and radiating on the nurse. Works of this nature served to establish her as an artist of worth. Other works issued with a World War I theme carried messages of hope and joy. "When Daddy Comes Marching Home" was released in January of 1919, signaling the end of World War I, and pictured the joy of bringing loved ones together again. Once again, in this work, she emphasizes the importance of family and of love.

"When Daddy Comes Marching Home" (Fig. 5-26) never achieved the popularity of other wartime prints, probably due to the fact that its subject was that of an afterwar scene. Few illustrations, however, have caught the emotions and joy of the returning soldiers as did this one, issued on the first day of the year in 1919. It features a huge American flag as the background,

and in the foreground a beautiful woman waves a handkerchief while holding her tow-headed son in her lap. On the street below a parade of dough boys marches by. It was a suitable and emotional way to announce that the war had ended. Such a scene could only have been depicted by a true patriot.

Her final picture, with a war theme, was issued on January 3, 1946, and it signaled the end of World War II. Bessie Pease Gutmann's message is one of deep feeling for those who made the supreme sacrifice during the war, and she expresses it through this illustration. A curly-headed boy in his pajamas blows a toy horn to his army of toy soldiers dressed in the Army, Marines, Navy, and Coast Guard uniforms of World War II. The picture is simply entitled "Taps" (Fig. 5-27).

The American Girl

Despite the fact that Bessie Pease Gutmann granted few interviews and maintained a private personal life, there is no doubt that she allowed us, from time to time, to understand what she was thinking through her art. Nowhere was this more evident than in her portrayal of young women. It is likely that

FIG. 5-29 "Sweet Sixteen" No. 601, April 23, 1909. (Collection of Susan and Warren Wissemann)

FIG. 5-30 "Buds" No. 603, March 25, 1909. (Collection of Susan and Warren Wissemann)

FIG. 5–33 "The Message of the Roses" No. 641, April 15, 1915. (Collection of Susan and Warren Wissemann)

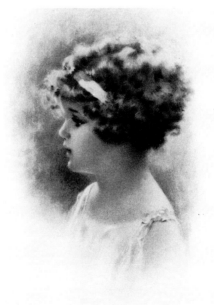

FIG. 5–34 "Peach Blossoms" No. 776. April 20, 1927. (Collection of Susan and Warren Wissemann)

this, her favorite subject, mirrored a self-image and provided an outlet for her emotions. She obviously enjoyed portraying women of the time who possessed a character as strong as their male counterpart's, but, above all, were never portraitures (Fig. 5-28).

In 1910 she was invited by the editor of *The Delineator* magazine to submit, along with other illustrators of the time, her concept of the American girl. Her response gives us an opportunity to know more about her personal standards, and, if you will, the moral code that she lived by, for the finished work was certainly an expression of herself. In "The American Girl" (1911) she comments: "The American girl has so many pursuits and pastimes that I preferred not to limit her with any of them. My ideal is entirely a creation of my imagination—and she is very elusive. In the back of the magazine we read that pearly teeth and a beautiful complexion are indispensable to beauty. Doubtless it is true, yet this elusive model of mine could never hold her throne without a lovely character. She must be not only clever and fascinating, but tactful and lovable, a good friend and comrade, possessing poise and graceful dignity. All these are essential in my ideal American girl."[61]

The charming young ladies of the time are paraded before us in an endless stream of beauty; "Sweet Sixteen" (1909), "Buds" (1909), "Sweetheart" (1910) (Figs. 5-29, 5-30, and 5-31), "A Brown Study" (1910), "The Vanquished" (1910), "Repartee" (1912), and "The Debutante" (1913), "Blossoms" (1914), "The Message of the Roses" (1915), "Peach Blossom" (1916) (Figs. 5-32, 5-33, and 5-34). Perhaps the message found in one of the two metamorphic works she produced, "Love or Money" (1907), of the young lady attempting to decide on a love-marriage or a marriage for money, lets us know the choice her American girl would make with regard to marriage; certainly, a marriage for love (Fig. 5-35). Bessie Pease Gutmann's American girl was also one that looked with disdain and a twinkle in her eye at the male dominated society of the period. Her work, "Merely a Man" (1910), pictured a young lady of that era, arm outstretched and palm open, holding a tiny man who is standing and tipping his straw hat to her (Fig. 5-36). This was rather a strong statement at the height of the women's suffrage movement and eleven years before voting rights for women was enacted.

Here Comes the Bride

Wedding themes and young couples were popular subjects with her. The works featuring adults were produced primarily in charcoal with overlays of oil and watercolor and were done over a period of fifteen years. Her husband's secretary, Esther Hilpultsteiner (she was a dear family friend and was called "Aunt Esther" by the Gutmann children) was Gutmann's favorite model for most of her wedding theme works. "To Love and To Cherish" (1911), picturing a beautiful and radiant bride descending a staircase, was the first for which she used Miss Hilpultsteiner as her model (Fig. 5-37). This work was an immediate success with the public and over the next few years others were created (Figs. 5-38–5-42): "To Have and To Hold" (1912), "The Bride" (1913), "The Wedding March" (1917), "The Fairest of the Flowers" (1918), "On the Threshold" (1924), and "Always" (1926). None of these, although artistically successful, succeeded in capturing the

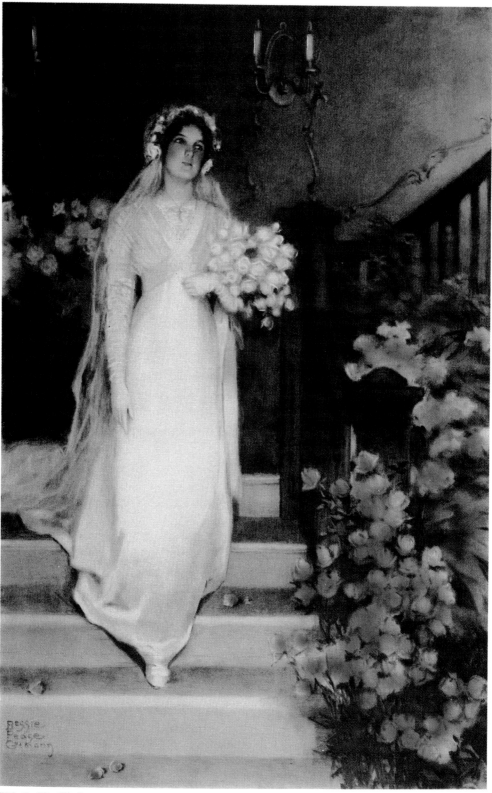

FIG. 5–37 "To Love
and To Cherish" No. 615,
December 4, 1911. (Col-
lection of Meredith and Jo-
seph Failla)

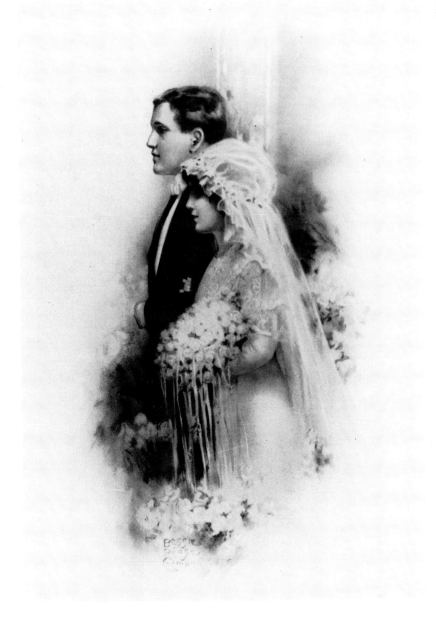

interest and loving response from the public, as did her first "bride" in 1911. In all of these works she utilized muted yet highly decorated backgrounds in order to frame the major subject and convey a portrait-like picture.

The Aureole of Youth

On May 18, 1921, the Gutmann & Gutmann firm copyrighted three of the most charming and unusual works of Bessie Pease Gutmann. The three pictures represented the only adolescents done by the artist. After consider-

FIG. 5‑39 "The Wed‑
ding March" No. 653,
April 20, 1917. (Collection
of Susan and Warren Wis‑
semann)

FIG. 5‑40 "The Fairest
of the Flowers" No. 659,
January 1, 1918. (Collec‑
tion of Meredith and Jo‑
seph Failla)

FIG. 5-41 "On the Threshold" collector's plate produced by Woodmere China Company, New Castle, Pennsylvania. Also issued as art print No. 731, January 25, 1924.

FIG. 5-42 "Always" No. 774, December 30, 1926. (Collection of Mary and Joseph Connors)

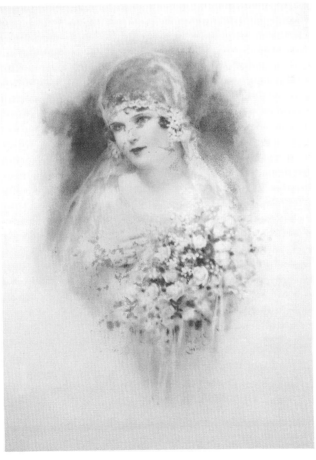

able coaxing and imploring, she photographed her oldest daughter Alice, who was a preteen at the time, and utilized the photo as her model for the finished works.

"The Winged Aureole" (1921), allegorical in nature, pictures a young girl feeding white doves while an aureole (halo or crown) of white doves fly about her head (Fig. 5-43). The composition of this work is such that the viewer becomes a part of the scene and the soft background light that it is bathed in. "Symphony" (1921) and "Wood Magic" (1921) are companion works that picture a young nude. They are a most delightful and tasteful portrayal of youth on the brink of adulthood (Figs. 5-44 and 5-45). The

FIG. 5-44 "Symphony"
Nos. 270 and 702, August
8, 1941. (Collection of
Eleanor and William
Popelka)

FIG. 5-45 "Wood Magic" Nos. 268 and 703, May 18, 1921. (Collection of Eleanor and William Popelka)

coloring and detailing of the background of rich greens and cool blues were overlayed with soft blue-green and yellow-green hues in pastels and watercolors, which were laid over fine etching-like lines. The color renditions of dominate blues and greens and other features showed the strong influence of her former instructor, Robert Henri. "Henri emphasized a combination of solid drawing techniques and careful attention to the balance of color and light. . ."[62] Bessie Pease Gutmann's use of light and shadows in these pieces demonstrated her full awareness of the decorative potentials of color.

Models were Everywhere

Bessie Pease Gutmann utilized two techniques when models were involved. She would work from a photograph making rough sketches of her subject with a charcoal stick. She would return to these sketches at a later date. She also used models that were immediately available to her, such as her own children and those of friends, relatives, and business acquaintances. "Children make rather good models, even though they are comparatively wiggley. . ."[63] she would say. She kept her camera ready at all times to capture special moments of the youngsters around her, although they weren't always a delight. "They are, of course, perfect little imps at times, and won't keep still for five minutes unless bribed to a most sinful extent."[64]

Once she had a small boy posing for an illustration that was to be entitled "The Moo Cow Moo," and he was supposed to be looking through the bars of a fence at a cow grazing in the pasture (Fig. 5-46). "We usually let them rest quite often," she said. "This little boy had only just started to pose. 'I wish I could sit down,' he complained. 'But you've only just started,' I reminded him. 'You wouldn't want to sit down to watch a real cow. You'd just stand there and watch him and you'd never even think of getting tired,' I persuaded him. 'Yes, but I wouldn't stand and look at a real cow this long!' the little child replied."[65] This sort of experience prompted her to make pictures of many children while they were asleep.

Most artists profess to despise the aid of photography when making their pictures. Bessie Pease Gutmann declared that the camera greatly assisted her at times in the portrayal of her child studies. Commenting on this, one interviewer noted that "she is a clever photographer herself, and is constantly snapping children in all sorts of poses of natural and unaffected poses."[66] It was her contention that children were difficult subjects to pose— not on account of their restlessness alone, but also because of their self-consciousness. She maintained a file of photographs of her nieces and her own children which were taken when her subjects least suspected. All of these photographs were subject to her study and analysis when she was preparing to create another child-life on canvas (Figs. 5-47, 5-48, and 5-49).

Her love and affection for children was never reduced to a maudlin state, nor did she believe in the relaxing of discipline. "She was careful to present a warm and wholesome atmosphere and was kind and loving to her child models but she made it clear that reasonable decorum was expected and she had a knack of accomplishing what she said."[67] She regarded children as the most original beings in the world and had much amusement listening to their remarks and endeavoring to answer their questions. One critic noted: "The frankness with which they (children) will criticize her work is sometimes a little disconcerting, but, after all, perhaps it is the only really, true criticism. Many an alteration has been made at the suggestion of the little sitter herself."[68]

Bessie Pease Gutmann was usually quite tolerant when the eye of one of her little posers regarded her work with cold disapproval. On such occasions she would take time to explain why she had done such and such a thing in a picture instead of turning a deaf ear to the child's remarks. But the youngster can very seldom be persuaded against her own judgment, with the result that

FIG. 5–46 "The Moo Cow Moo," from *Chronicles of the Little Tot* by Edmund Vance Cooke. New York: Dodge Publishing Company, 1905, p. 66.

FIG. 5–47 "Watchful Waiting" No. 679, May 1, 1919. (Collection of Eleanor and William Popelka)

FIG. 5–48 "Going to Town" No. 797, July 29, 1938. (Collection of Susan and Warren Wissemann)

FIG. 5–49 "Teddy" an original 3″ × 4″ charcoal sketch of a one year old subject by Bessie Pease Gutmann. ("Teddy" was the nickname of the owner of the sketch.) (Courtesy of Col. Frederic A. Frech [Ret.])

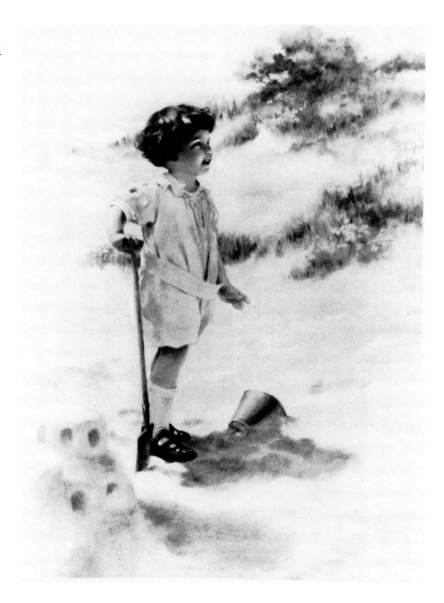

an alteration has been necessary. It is very seldom that a real unaffected child
pauses to consider whether her remarks will cause pleasure or pain, and
hence the criticism must be the most unbiased of all."[69]

Her son John served as a model for many of his mother's works. Bessie
Pease Gutmann produced a number of charming pictures which illustrated
how she was able to convert some of the simplest of life's situations into an
artwork that was regarded as a delightful rendering of child-life. One of
these, "The Aeroplane" (1921), a work in charcoal and tempera, depicts
John at the age of three, stopping work on his sand castle to scan the sky for
an aeroplane (Fig. 5-50), a phenomenon in that year. The artist captured the
tone of innocence and natural interest in the radiant face of the child.

Another work, "The New Pet" (1922), shows the natural curiosity of

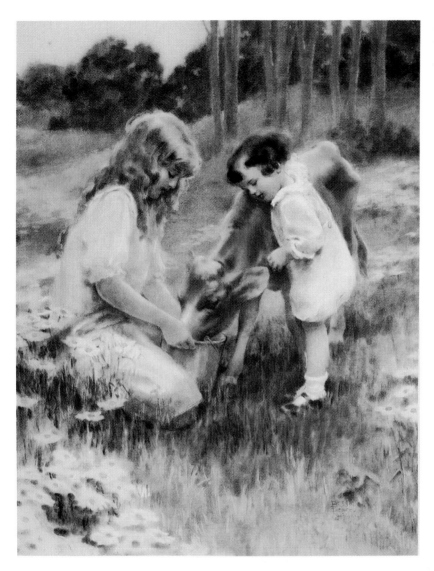

FIG. 5–51 "The New Pet" No. 709, June 3, 1922. (Collection of Meredith and Joseph Failla)

FIG. 5–52 Photo showing models Alice and John for the artwork. (Courtesy of Alice Gutmann Smith)

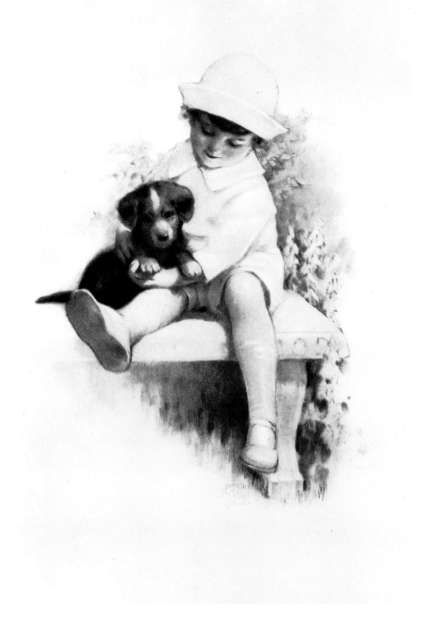

youth with Alice and her brother John feeding a newborn calf from a milking can. The artist placed her three subjects in a colorful and flowering meadow which produced a natural framing for the theme (Figs. 5-51 and 5-52). The use of an overlay of watercolor and charcoal produced a subtlety of color and perspective which, in turn, created lifelike images. In "Buddies" (1928), she again captured in watercolor one of her favorite subjects, a child and his pet. This time, both subjects are seated on a garden bench and are obviously interested in only each other and certainly not the artist, which resulted in a charming study of youth (Fig. 5-53).

Other works and the models used to produce them were: "Chums" (1981) [Alice, her oldest daughter]; "The First Dancing Lesson" (1923) (Figs. 5-54 and 5-55) [Margaret Alcott Frech, daughter of sister Mary]; "His Majesty (1936) (Fig. 5-56) [Billie Albury, son of friends in the Florida Keys]; "In Disgrace" and "The Reward" [Teddy, a collie owned by Fred Fulton, friend of the Gutmanns]; "Harmony" (1940) (Figs. 5-57 and 5-58) [Lois Rubino, daughter of Gutmann friends in Orlando, Florida]; "Sympathy" (1941) [Billy, son of William and Lucille Horrocks]; "Perfect Peace" (1943) [Betsy Hackland Walsh, daughter of Alice Gutmann Smith]; "Rollo" (1914) [their own horse Silver Heels]; "Dorothy" (1911 postcard) [daughter of brother Willie]; "Betty" (1911 postcard) [Betty Watkins, daughter of neighbors in South Orange]; and "Margaret" (1911 postcard) [oldest daughter of sister Mary].

All God's Creatures

It was quite common for Gutmann's pictures to show her children being accompanied by some creature. It has been estimated that more than half of all her published works featured some type of animal pet (dogs, cats, calves, birds, butterflies, fish, ponies, rabbits, chickens, mice, geese, and even pigs). Dogs of all breeds appear in a majority of her works.

She was very careful in her rendering not to have the animal dominate the theme of the illustration, however the pet *was* given a role of importance. Her sketch books show hours and hours of work trials using a variety of animals, and studies that indicate she was seeking expressions and body positions that would be natural and pleasing to those who viewed it (Figs. 5-59, 5-60, and 5-61).

Prime examples of her use of animals in her works are found in the 1914 series of four children and four different pets: "Tabby" (cat), "Bunny" (rabbit), "Rollo" (pony), and "Rover" (dog). These small, nine by twelve inch prints were part of the Gutmann & Gutmann Company's 100 series and were delightful works that proved to be one of the firm's most successful groupings. Gutmann wisely chose to use simple charcoal lines overlayed with watercolor, all imprinted on white paper stock, and without any decorative background art. A photograph of daughter Alice and her little spotted puppy was the foundation for one of her most admired works and a classic piece of art, "Chums" (1918). It was an ambitious and large work of oil on canvas over charcoal. It demonstrated her remarkable skill with the use of oils to achieve a sensitive and delightful scene of a nude baby and her puppy dog. By using varying shadings of cobalt blue she captured the natural charm and joy of the two subjects (Figs. 5-62 and 5-63).

One of a Kind

It wasn't too long after the turn of the century, when the fine art print industry began to flourish, that competitiveness developed. The firm of Gutmann & Gutmann was aware that baby pictures had saturated the market and requested its chief artist, Bessie Pease Gutmann, to create an unusual, one-of-a-kind print. This set of circumstances freed her from limiting subject restrictions and permitted her to explore other artistic subjects.

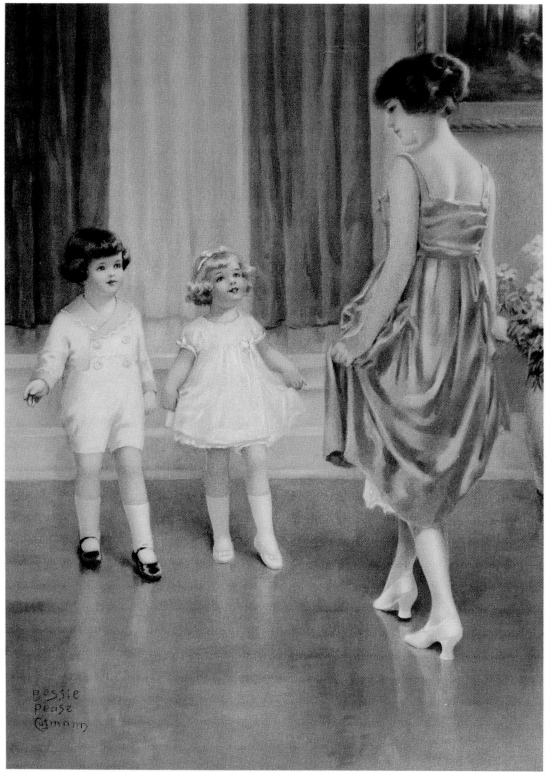

FIG. 5–54 "The First
Dancing Lesson" No. 713,
February 13, 1923. (Col-
lection of Susan and
Warren Wissemann)

FIG. 5-55 Original charcoal sketch of Margaret Alcott Frech, niece of Bessie Pease Gutmann, and mother of Col Frederic A. Frech (Ret.). The sketch, 1' × 2', served as the model of the lady shown in "The First Dancing Lesson." (Courtesy of Col. Frederic A. Frech [Ret.])

Hellmuth, the business person, was ever aware of market trends in the print industry and would from time to time request that a particular subject be produced. This was the case in early 1925 when a request was made to create a picture featuring a black child. Twenty years before that she had painted a picture of a little black girl blowing bubbles and called it "Little Black Blew" (1906). Prior to that, during her investigative illustrating period, she had pictured children of all races in her illustrations. It was characteristic of the times for illustrators to draw caricature figures of the

races, but Bessie Pease Gutmann would have none of that. It was totally contrary to her beliefs. The resulting work, "My Honey" (1925), was marketed in early 1926 and represented one of the few sensitive and delightful portrayals of a black baby by any illustrator until that time (Fig. 5-64). She utilized the same techniques and style that had achieved so much success for "A Little Bit of Heaven." The work was completely free of any distracting background and, with the use of charcoal and subtle shadings of color, she was able to create a picture of a charming, chubby-faced child looking right at the viewer and capturing the hearts of all who saw it.

Many of her book illustrations were published as art prints. Her contract with the Dodge Publishing Company of New York granted them the right

FIG. 5-57 "Harmony" No. 802, August 23, 1940. (Used by permission of The Balliol Corp.)

FIG. 5-58 Photo of Lois Rubino, Orlando, Florida, model for the child in "Harmony." (Courtesy of Alice Gutmann Smith)

to publish, at their discretion, book plates as prints. One of the most delightful of these came from the 1906 book authored by Edmund Vance Cooke, *Told to a Little Tot*. One of the stories in the book told of a cat, Tabitha, who had opened a school. The story, "How Miss Tabitha Taught School," and its accompanying illustrations by Bessie Collins Pease, told of Tabitha's first pupils, ten mice. The picture shows Miss Tabitha looking down at her pupils (Fig. 5-65). According to the story, each day the mice went home from school their number had diminished by one, and it wasn't long before Miss Tabitha had run out of pupils to teach. The Dodge Publishers also reissued several other color plates as prints which had appeared in the 1905 book by Edmund Vance Cooke, "Chronicles of the Little Tot." They changed the book plate titles on some of them and "A Christmas Kid" was marketed as "Christmas" and "Baby on the Floor" became "The Sunshine of the Home."

FIG. 5–62 "Chums"
Nos. 263 and 665, No-
vember 25, 1918. (Used
by permission of The
Balliol Corp.)

FIG. 5–63 Photo of
Alice and puppy, models
for "Chums." (Courtesy of
Alice Gutmann Smith)

MY HONEY

FIG. 5–64 "My Honey"
No. 756, January 5, 1926.
(Collection of Susan and
Warren Wissemann)

In 1909 she accepted a commission from the Robert Chapman Company of New York to prepare several general artworks featuring children in varying stages of play. It would appear that the works which fulfilled the contract had been completed many years before since they characterized the style and technique of the artist's early years. Most of these pictures were sold to book publishing companies who used them as illustrations, however the Robert Chapman Company issued four of these as art prints— "Crowning the May Queen" (Fig. 5-66), "Preparing for the Seashore," "Serving Thanksgiving Dinner," and "Playing House."

From Songs to Prints

In the genre of the times, Bessie Pease Gutmann would often use the titles of popular songs for her pictures: works such as "Smile, Smile, Smile" (1918), "Sonny Boy" (1929), "School Days" (1908), "Mighty Like a Rose" (1915), "Till We Meet Again" (1905), and others. She chose part of a well-known hymn to heighten interest in the only work she did which featured a baby, mother, and father. "The Tie that Binds" (1910) is a delightfully sentimental picture which again demonstrated the versatility of her art (Fig. 5-67). The illustration shows a mother and father looking down at their newborn resting in a beautiful bassinette. Both parents have eyes only for their baby,

FIG. 5–65 "How Miss Tabitha Taught School" copyrighted by the Dodge Publishing Company, 1906. Also appeared in *Told to the Little Tot* by Edmund Vance Cooke. New York: Dodge Publishing Company, 1906, p. 10. (Collection of Susan and Warren Wissemann)

Into a Gentle World—Fine Art Prints

who is raising arms and legs in apparent joy, causing the viewers' eyes to focus on the child. The theme of the work is emphasized by the use of soft hues of pastels, charcoal, and a decorative background.

Poetry and Dolls Too

Bessie Pease Gutmann enjoyed poetry in all its forms, so it was quite natural that she would find a way to merge her artwork with poetry. Over the years, she wrote original bits of poetry that illuminated some of her pictures. Some of the works that featured her poetry in the Gutmann & Gutmann catalogs were: "Love is Blind" (1937), "Sympathy" (1947), "Bruzzer had a Fever" (1909) (Fig. 5-68), "Cupid: After All My Trouble" (1911), and "The Reward" (1936). When "The Reward" and its mate "In Disgrace" (1935) were sold in the 5 & 10 Cent stores (Woolworth's, McCrory's and Kresge's) and department stores in the 1930s, they affixed to the back of each print a sticker-poem printed in blue ink on thin, glossy, white paper stock. The copyright admonition of "These Copies Not To Be Sold" was intended to prevent the little slips of poetry from being sold separately.

It was, however, her employment of dolls in her work that was most appealing to her fans. Dolls were (and are) a very important part of childhood, so her art depicted children and their dolls in natural settings. Two of her works featured a plethora of dolls, all with different features minutely defined and contrasting sharply with each other. "A Busy Day In Dollville" (1911), which made its appearance on an advertising tin and was possibly issued as a print by the Diamond Dye Company, had five dolls pictured. "Who says Race Suicide" (1907), which appeared as a postcard titled "The Happy Family" (Fig. 5-69), featured a total of thirteen lifelike dolls. The doll which attracted the most favorable response was the one shown in the 1937 rendering of "Love is Blind" for it is believed to be from the Art Deco period of doll maker Madame Lenci of Italy.

FIG. 5-68 "My bruzzer had a fever," the first line of poetry written by Bessie Pease Gutmann to accompany this 1909 postcard. The same subject was issued as an art print under the title of "The Water Cure" but it was quickly changed to "Brother Had a Fever" No. 212, April 10, 1909. (Author's collection)

The Treasure of Fairy Gold

Efforts by friends and offers of commissions for Bessie Pease Gutmann to do portraits of children were constantly before her. She resisted becoming a portrait artist because she believed that the problems associated with sittings, dealing with parents-turned-art-critics, and deadlines were far too restricting and not worth the anxiety caused. She did, however, at the age of sixteen, do a self-portrait using pencil, tempera, and watercolor to create a lovely and sensitive work that gave evidence of her talent for portraits.

While resisting efforts to produce portraits she continued her work with babies and children, creating from her own imagination. In the 1920s and early 1930s she created a series of paintings that had the appearance and quality of portraiture work. This series, contrasting with previous work, featured single images of children in head or bust form. It was her brother-in-law, listed Post-Impressionist Artist Bernhard Gutmann, who com-

FIG. 5–69 "The Happy Family" No. 301, April 6, 1907. Originally issued under the unpopular title "Who Says Race Suicide?" (Author's collection)

mented that Bessie Pease Gutmann had reached the pinnacle of her artistry with such work, in particular "Fairygold" (1926).

"Fairygold" (Fig. 5-70) was unlike any of her previous works, for it pictured a child's head with a three-quarter profile. The wistful, golden haired, curly-headed child looking out from the canvas was not just another pleasant young child created from imagination. This oil over charcoal with only the most minimal of background shading was a dimensional human with a distinct personality. The creation was a different Bessie Pease Gutmann. Gone were the broad lines, bright colors, and considerable decoration. In their place is found subtle contrasts and delicate shadings of harmonious colorings which create a sense of depth and realism.

Two of the subjects in the series (Figs. 5-71 and 5-72), "Goldilocks" (1921) and "Snowbird" (1929), were rendered in a style similar to the portrait studies of the period. "Goldilocks" pictures a beautiful, cherubic girl. Her long and golden ringlet curls frame her lovely, glowing face. "Snowbird," an oil on canvas, is a study in soft hues with white, blue and black predominating and a "Gutmann face" looking out from underneath a white fur hat. A background of flowing light colorings frames and

FIG. 5-70 "Fairygold" No. 770, December 30, 1926. (Collection of Eleanor and William Popelka)

highlights the image. Most of these portrait-like works were produced with white backgrounds, such as "Sonny Boy" (1929), "Contentment" (1929), "Sunny Sonny" (1928), "Peach Blossom" (1927), "Good-Bye" (1929), "Betty" (1931), and "Billy" (1931). Despite the absence of backgrounds, these works do not have the appearance of stiffness nor stiltedness (Fig. 5-73).

The paired prints "Mischief" (1924) and "Sunbeam" (1924) were purely creations of the artist and are avidly sought after by Gutmann aficionados (Figs. 5-74 and 5-75). Both feature the same child's face—"Mischief" with dark hair and "Sunbeam" with golden curly hair—with such expressive eyes that the viewer knows exactly what is going on in their heads. Using temperas and watercolors over charcoal, the artist worked within circles thirteen inches in diameter and created two charming images that were neither boy nor girl, but children who could be a delight one moment and mischievous the next. They were so successful that several printings were required to meet the demand of the public. Most people desired to purchase

GOLDILOCKS

"Mischief" alone which accounts for the difficulty in locating this print today.

The Divine Fire

Many of the works completed by Bessie Pease Gutmann in the first two decades of her life have titles that are not understood today, and this causes some confusion. Unless one were alive when crystal sets (the forerunner of the radio) were utilized to listen to the news or to hear early story hours, the work "The Bedtime Story" (1923) would require some explanation (Fig. 5-76). This intent child, sitting in a chair that also appeared in "The Great

Love" (1919), has headphones on which are hooked up to a crystal set, and is listening to the customary bedtime story hour. The viewer knows that the child is getting ready for bed because both shoes and one sock are off. In another picture we see a young child, obviously very distressed, standing up in his crib. The print was issued in 1912 when Morse Code expressions were used and its caption, "C.Q.D," means Come Quick Danger (Fig. 5-77).

"The Divine Fire" (1923) is a mystical illustration of a young boy seated on the first step of a staircase in a typical Mediterranean-style stucco home, a look of dreamy contemplation on his features, and holding a homemade guitar-like instrument in his hands (Fig. 5-78). The clue to understanding this dark and somber print is in its title and the identification of a portrait hanging on the wall behind him. The portrait is of the great Spanish guitar virtuoso, Andres Segovia. The Gutmanns heard him play at an art-music recital during his European tour in the early 1920s. Segovia, referred to as the world's greatest guitarist, played with such fervor that it was said his music had "the divine fire." So impressed was Mrs. Gutmann with Segovia's performance that she produced this print of a young Spanish lad dreaming of one day making music like his idol, Segovia.

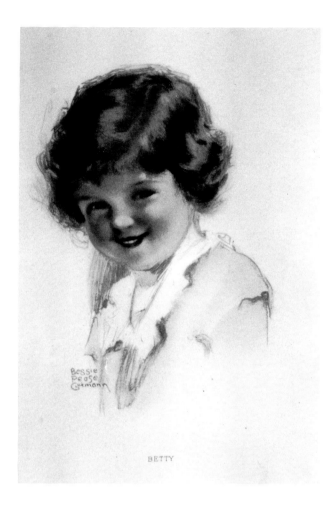

BETTY

German legend had it that Lorelei was a siren of the Rhine whose beauty and singing distracted sailors and caused them to wreck their ships. Bessie Pease Gutmann transformed the legend into a young girl in a period bathing suit, replete with stockings, seated on the craggy rocks along the Atlantic Ocean on the coast of Maine. This "Lorelei" of hers shows us another side of the artist who, with watercolors and oils, presents a picture of a very shapely young lady, looking pensive as the waves break around her, and whose shoulder strap has fallen provocatively over her left arm, showing considerable anatomy for the year 1915 (Fig. 5-79).

Two are Better than One

Two are better than one could have been applied to the work of Bessie Pease Gutmann's "A Double Blessing" (1915). The print was a stroke of marketing genius when it appeared in department stores of the era. Twins had rarely been featured in prints up until that time, so the Gutmann firm was the first to offer them on a national basis. The images of two adorable babies, lying side by side in a bassinette that had ruffles and a huge bow, was irresistible (Fig. 5-80). The subjects, fast asleep, with their little white lamb hanging on a silk ribbon from the side bar, was characteristic of the artist.

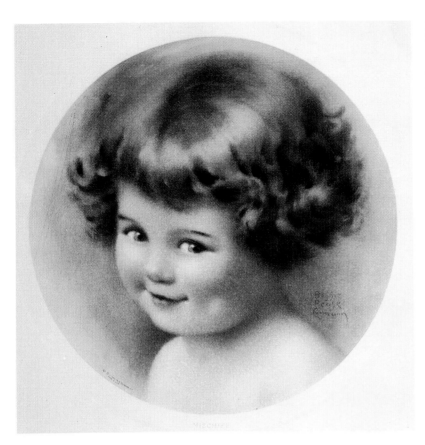

FIG. 5–74 "Mischief" No. 729, January 25, 1924. An earlier subject (No. 122) was issued with the same title but different subject on January 10, 1907. (Collection of Eleanor and William Popelka)

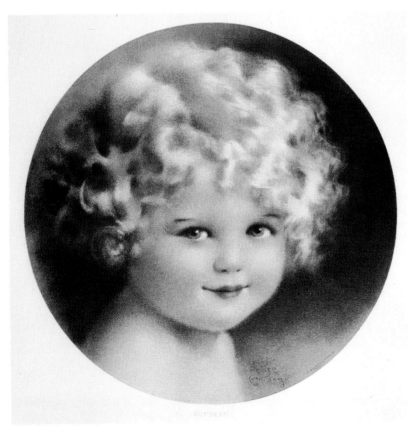

FIG. 5–75 "Sunbeam" No. 730, January 25, 1924. (Collection of Eleanor and William Popelka)

FIG. 5–76 "The Bedtime Story" No. 712, February 13, 1923. (Collection of Wendy J. Christie)

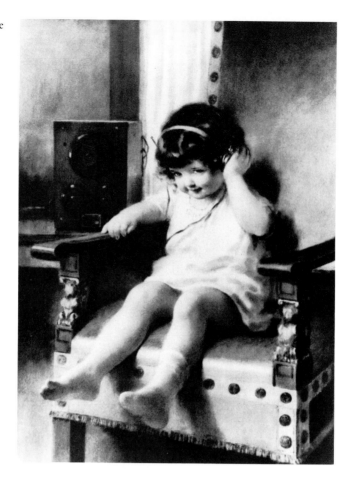

FIG. 5–77 "C.Q.D." No. 149, November 15, 1912. (Collection of Susan and Warren Wissemann)

FIG. 5-78 "The Divine Fire" No. 722, February 13, 1923. (Collection of Susan and Warren Wissemann)

Muted colorings and delicate shadings created an atmosphere of trust and love. In marketing this print, both bow and ribbon colors were changed to yellow, pink, blue, and sometimes combinations of two colors so as to increase their sales appeal.

A Threesome

Three prints which were not intended to be placed together, for they were not completed within the same time frame, were eventually teamed because

FIG. 5–79 "Lorelei" No.
645, November 26, 1915.
(Collection of Susan and
Warren Wissemann)

FIG. 5–80 "A Double Blessing" Nos. 232 and 643, June 1, 1915. (Collection of Susan and Warren Wissemann)

FIG. 5-81 "Daddy's Coming" Nos. 223 and 644, November 26, 1915. (Author's collection)

FIG. 5-82 "Introducing Baby" Nos. 614 and 646, April 1, 1916. (Author's collection)

FIG. 5–83 "The New-comer" Nos. 262 and 685, December 10, 1919. (Collection of Julie and Tom DeLuca)

of their subject matter and hanging dimensions. Very few works of Bessie Pease Gutmann were prepared so the images appeared oblong on the standard fourteen by twenty-one inch stock paper. "Daddy's Coming" (1915), "Introducing Baby" (1916), and "The Newcomer" (1919) were three of the exceptions (Figs. 5-81, 5-82, and 5-83). To the observer they have several things in common. They all picture children showing normal interest and curiosity in ordinary circumstances. The child standing on the window seat waving to his Daddy, the child being shown his new brother or sister, and the little fellow leaving his toy soldiers for a moment to peek at the new one in the bassinette are all ordinary scenes. Bessie Pease Gutmann rendered them extraordinary in her art. The techniques used to create these three works involved careful decorations of backgrounds which were subdued so as not to detract from the central and simple theme. Those who look at these three prints are touched by seeing a gentle and loving America of long ago.

The Gutmann Colonials

In an effort to capture some of the market created by the popular Wallace Nutting framed, mounted, and hand-tinted photographs, Hellmuth Gutmann directed his staff artists to create similar works. Artists Bessie Pease Gutmann, Eda Soest Doench, and Meta Morris Grimball set to work immediately preparing a series of charcoal and pencil drawings that resulted in single-line printings. The prints, utilizing the colonial period of the country's history, were etching-like and hand-tinted with watercolor, and released to the public on April 1, 1916. These Gutmann colonials were produced and marketed for a three-year period but were never accepted as substitutes for the hand-colored photographs of Nutting.

The Gutmann colonials, although considered inferior to their photographic cousins, were superb single line renderings by the company's three artists and represented some of their finest technical efforts. The prints were issued in five different sizes and, at the end of three years, over fifty different pictures were issued. Company records were not kept of this phase of the firm's activities, so only an estimate can be made of the number of works that were prepared, converted into prints, and marketed. New "discoveries" of these prints are reported each year.

Gutmann & Gutmann, in an effort to compete with the Nuttings, mounted their prints on paneled stock and inscribed in pencil the title in the lower left of the print. "Gutmann" or "Grimball" was signed in pencil in the lower right. Confusion over these "signatures" ended when a former employee of the firm admitted that they were not the signatures of the artists but simply the work of office employees of the Gutmann firm. A casual glance at the "signatures" reveals wide variations of handwriting.

Bessie Pease Gutmann is known to have created at least five of the colonials: "Harmony," "The New Home," "Peach Blossoms," (Fig. 5-84), "Reveries," and "Yes or No?" These prints were considered to be of high artistic quality and were reissued as fine art prints in the standard size of fourteen by twenty-one inches. "Peach Blossoms" (1916) was one that was assigned a publisher's number (649) and is a colorful watercolor over charcoal print of a young colonial girl in period dress, a wide brimmed hat on the ground before her, standing in the midst of magnolia blossoms. "Harmony" (1918) is an indoor scene of a young colonial lady seated at a harpsichord and is highlighted by careful detailing of furnishings and indoor floral arrangements. Both of these prints show the artist's attention to minute details which required some research and, through the use of color tones, created an atmosphere of a beautiful and graceful time in our country's history.

Cherubs and Cupid

The year 1912 found Bessie Pease Gutmann beginning to demonstrate a maturity of style to express confidence in her subject selections. By this time, her brush, pen and pencil had created well over 160 art prints for the Gutmann & Gutmann firm. She had long since abandoned the single, broad-line illustrations which depicted simple messages. The background of her subjects became more evident and carefully developed so as to provide a balance and a pleasant flow of color. Alice Barber Stephens, who recognized

FIG. 5–84 "Peach Blossoms" No. 649, April 1, 1916. This print was one of the ill-fated Colonial series of Gutmann & Gutmann. (Collection of Susan and Warren Wissemann)

the necessity of a variety of skills as well as originality, proudly concluded, "The true illustrator . . . must have the facility of the actor and novelist as well as artist."[70] In this respect, Bessie Pease Gutmann moved away from her contemporaries who were still using the same medium and style and whose work superficially resembled each other's.

She began to utilize a characteristically natural and softer style by first

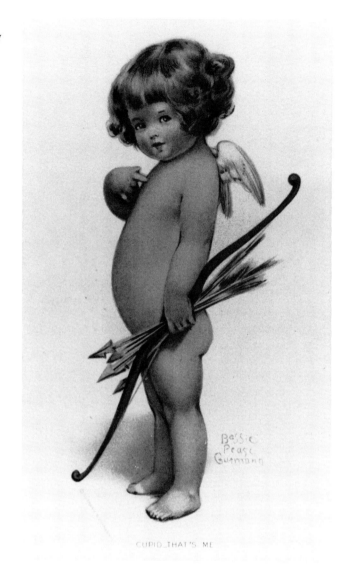

FIG. 5–85 "Cupid, That's Me" No. 249, July 26, 1911. One of several prints marketed by The Ohio Art Company of Bryan, Ohio, in their distinctive brown metal frames. (Author's collection)

CUPID_THAT'S ME

lightly sketching her subject in soft tonal charcoal pencil and filling in the spaces with delicate tones and color washes, thereby creating an almost mystical or ethereal effect.

She took great delight in using as her central subject Cupid or cherubs to develop this new approach (Fig. 5-85). Cupid and cherubs had been utilized by other artists to illustrate contemporary stories, but generally in a satirical or hard-lined pen and ink style. Bessie Pease Gutmann imagined a beautiful Cupid looking skyward, entranced by a butterfly. "The Butterfly" (1912) charmed the public from the day it was released as an art print (Fig. 5-86). The public, by 1912, had grown somewhat tired of seeing children in all sorts of daily activities and were demanding something else. The new subject would, however, still have to maintain the freshness and charm of the early babies and children. With "The Butterfly" she furnished the market with a

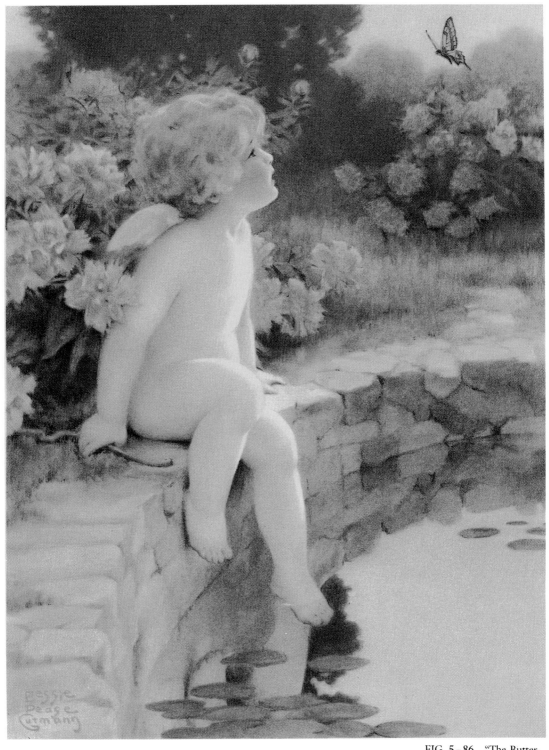

FIG. 5–86 "The Butterfly" Nos. 234 and 632, May 1, 1912. (Author's collection)

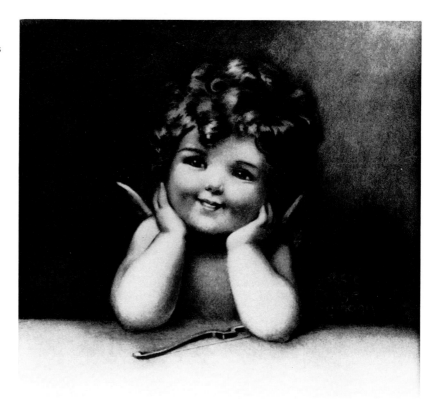

form of pure fantasy and escapism art. It was a masterful work with a quality and theme that was refreshing. Cupid, content to watch the beauty of a fragile butterfly, created an image that appealed to a variety of audiences.

"The Butterfly" had already appeared when a major set of paired pictures, which also featured Cupid, was issued. The two works, "Mischief Brewing" (1912) and "Caught Napping" (1912), were marketed in a smaller size than "The Butterfly" and were printed initially in a sepia-color ink (Figs. 5-87 and 5-88). The darkened brown color was heavy and did not take tinting well, consequently, although the subjects were delightful, the two prints never achieved the success of "The Butterfly."

A companion to "The Butterfly" appeared twenty-three years after its initial release. "Love's Harmony" (1935) featured the same Cupid sitting on the same wall as in the former work. This time, however, the Cupid is leading a chorus of bluebirds in heavenly song. This work has the same soft, delicate toning created with watercolor washes as its earlier relative and it illustrates one of Gutmann's favorite subjects, the bluebird. Both of these prints expressed a quality of the artist that was to be found in many of her prints and which few of her contemporaries would achieve. They were not only a beautiful escape form but, once having witnessed the work, the viewer was left with a feeling of peacefulness and tranquility. This particular print was one of the last that would be turned over to colorists for the application of color, for now, with the advancements in color lithography, most colorings would be applied by printer's ink (Figs. 5-89 – 5-94).

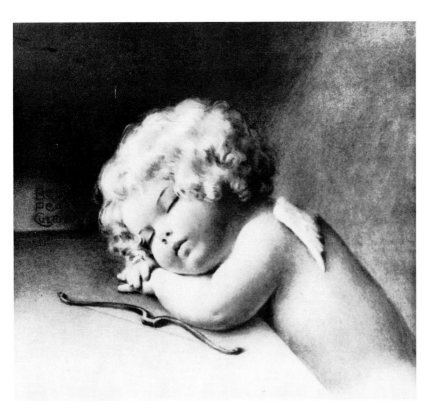

FIG. 5–88 "Caught Napping" No. 153, November 7, 1912. (Author's collection)

FIG. 5–89 "The Kiss" No. 612, July 26, 1911. This was reproduced from the original art that was 21″ × 25″ oil over charcoal on illustration board. (Private collection)

FIG. 5-90 "Springtime"
No. 775, April 20, 1927.
(Collection of Mary and
Joseph Connors)

FIG. 5-91 "The Bluebird" Nos. 265 and 266, November 25, 1918. (Collection of Susan and Warren Wissemann)

The Great Love

Babies were considered to be highly marketable subjects and the next best sellers were those pictures which showed a mother and child. It is in such works that Bessie Pease Gutmann had the opportunity to express her joys with motherhood and she illustrated mothers engaged in all types of joyous experiences with their children. She used bright and cheerful watercolors (usually over charcoal pencil) to achieve the feeling of joy and happiness. No longer harnessed by the heavy single line drawings of the early days, she employed a more natural style than the highly stylized form of the past. In doing so she created images that were real life, and her subjects came alive on her canvas. In each of these renderings, of which there were over thirty, the viewer gets the impression that they are self-portraits of the artist with her own children. These works are cherished bits of the past which continue to bring joy, and sometimes tears, to those that see them. "The Great Love" (1919) was, without question, a self-portrait of the mother-artist with her son John (Figs. 5-95, 5-96, and 5-97). Even some of the titles of the works, which were personally selected by the artist, reflect some of her inner feelings (Figs. 5-98 – 5-102): "My Darling" (1910), "I Love to be Loved by a Baby" (1909), "Dreams Come True" (1914), "A Priceless Necklace" (1915), "The Sweetest Joy" (1911), "The Mothering Heart" (1916), "Bud of Love"

FIG. 5–92 "Love's Message" No. 652, April 20, 1917. (Collection of Susan and Warren Wissemann)

FIG. 5-93 "In Arcady" Nos. 269 and 701, May 18, 1921. (Collection of Susan and Warren Wissemann)

(1912), "Reflected Happiness" (1923), "Baby Mine" (1912), "Heart's Ease" (1921), "Mother Arms" (1922), and "Sister" (1933).

A unique opportunity is provided for the study of the technology of Bessie Pease Gutmann in the process of creating an artwork. In July 1918 a photograph was taken of her in her studio as she sat in an ornate, heavily carved chair, cradling her son John, who was then three months old. Immediately behind her is seen the large oil painting of "Chums" which was to appear as an art print later that year. The photo shows her holding John in her left arm with separated and extended fingers. She decided, a short while later, to make some preliminary charcoal sketches using the photograph as

her model. The initial sketches show the fingers undefined and blurred, however, the features of the chair are clearly shown. Finally, in the completed work, which became the print "The Great Love" (1919), all background is removed and this beautiful and sensitive watercolor shows the fingers on the left hand completely closed but clearly shows the wedding band that had appeared in the original photograph. This work was certainly one occasion where she was both the model and the artist.

The Subject was Babies

Bessie Pease Gutmann did not aspire to paint babies at the outset of her career. "The foremost baby artist of the century" may not have been

Into a Gentle World—Fine Art Prints

completely overjoyed with such a restrictive pronouncement of her artistry. She certainly demonstrated throughout her long career that her talents were many faceted and that she was comfortable depicting children, teenagers, adults, animals, and other subject forms, in addition to babies. In the early 1900s, babies were the predominant subjects for the unsigned advertisements that she did. However, these were primarily single hard-lined drawings with little or no shading and very little thought to composition.

Her babies first began to appear, with some consistency, with the appearance of "Baby's First Christmas" (1910) which coincided with the first Christmas of her second daughter, Lucille. This picture of a charming chubby-faced little tyke is a "Gutmann Baby." Utilizing the heavy line border that was so characteristic of her contemporaries, she presents a fully disarming image of a contented baby with a top knot of hair, surrounded by Christmas toys and propped up against a pillow, looking at the viewer. Your first instinct is to hold out your finger for the tiny hand to grasp. The simplicity of this charcoal drawing belies the skillful hand of the creator whose talent could illicit paternal feelings from all who witnessed the finished work. The public responded to the print and it was issued as a postcard in the same year.

"Sunshine," "Baby Mine," and "Baby's First Birthday" (Fig. 5-103) all followed in 1912. With the appearance of "Our Alarm Clock," "His Majesty" (the same title with a different subject was issued in 1936), "All is Vanity," and "Come Play with Me" in 1913, the babies were being consistently painted and rendered into art prints. Baby prints were marketed on a regular basis, but it wasn't until the art print classic "A Little Bit of Heaven" (1916) appeared that such subjects became a major part of the art print trade.

"Mermaid Pearls" (Fig. 5-104) was issued in 1915. The print was unsigned and copyrighted by Gutman & Gutman (sic). A similar subject of a baby mermaid was found on a German language postcard and signed "B. Gutmann," which was characteristic of the signature of Bernhard Gutmann, the brother-in-law of Bessie Pease Gutmann. The translation of the card gave it the title of "Waterlily," however, it is speculated that the image was actually "The Baby of the Lake" issued in 1906.

The Young Adults

The popularity of her "babies" eclipsed the many works that Gutmann created which featured adults. The young adult love theme in the fine art print field was simply not popular at the time and Gutmann & Gutmann marketed very few. Some, however, were completed and represented an artistic achievement for the artist.

To the student and collector of Bessie Pease Gutmann art, the man and woman illustrations that she did represent a complete artistic range. "Verdict—Love for Life" (1909), "Cupid's Reflection" (1909), "The Tie That Binds" (1910), "To Have and To Hold" (1912), and "Home Builders" (1917) were all works that featured a young couple (Figs. 5-105 – 5-108).

The United States entered World War I in April 1917 and, in the same month, "Home Builders" was released. The country was ready for such

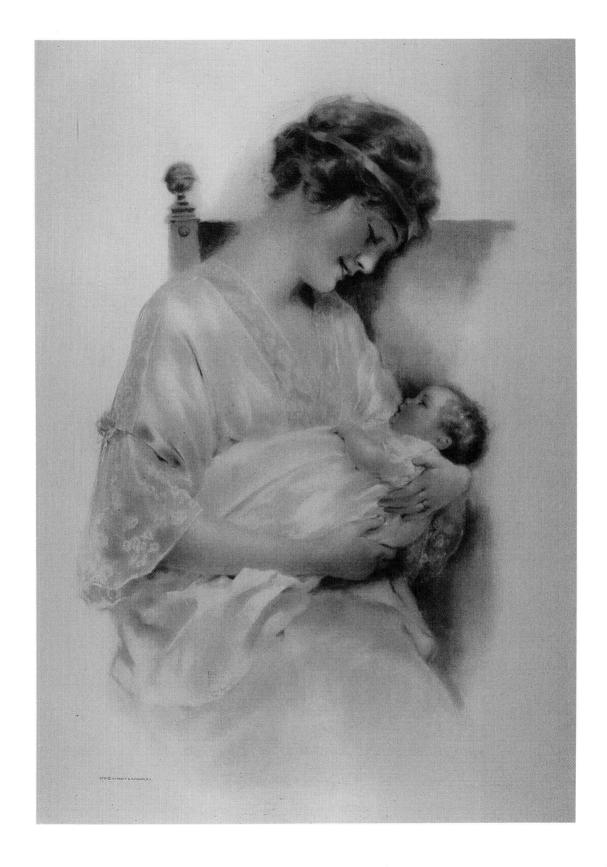

137

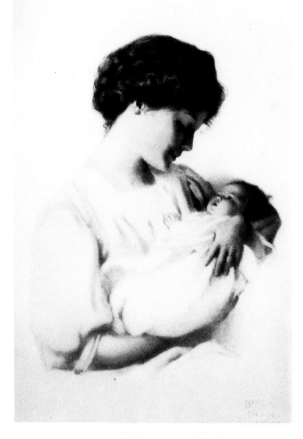

FIG. 5-99 "A Priceless
Necklace" No. 744, Janu-
ary 24, 1925. (Used by
permission of The Balliol
Corp.)

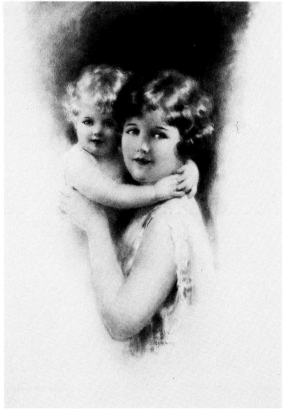

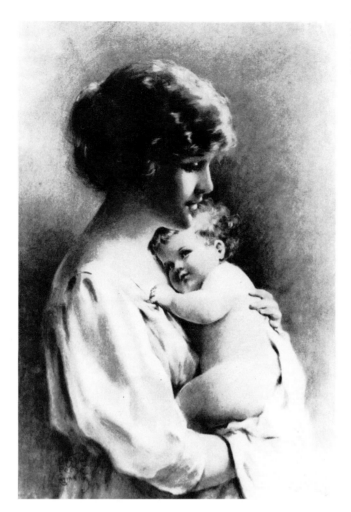

FIG. 5-100 "The Mothering Heart" No. 331, November 25, 1918. (Collection of Susan and Warren Wissemann)

sentimentality and innocence and the print was a marketing success. The artistry was bright, cheerful, and featured a young couple dreamily watching nesting blue birds. A mixed media of charcoal, pastels, and oil, the work includes apple blossoms, a textured fieldstone wall, and vivid purple thistles in bloom. It demonstrates the artist's use of color hues to create a viewer attitude of happiness and the promise of a better world in the future. "Home Builders" is a popular print today for undoubtedly the same reasons it was in 1917.

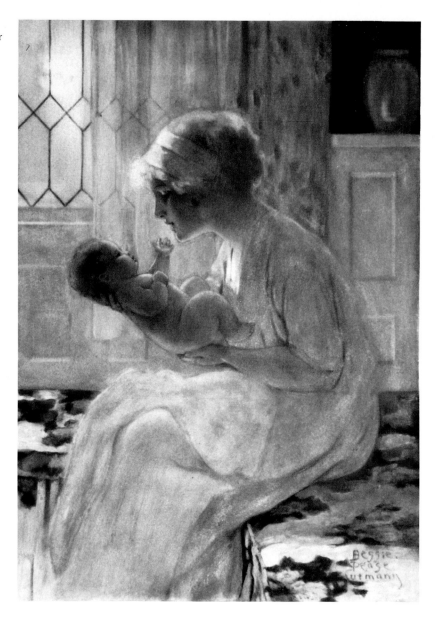

Into a Gentle World—Fine Art Prints

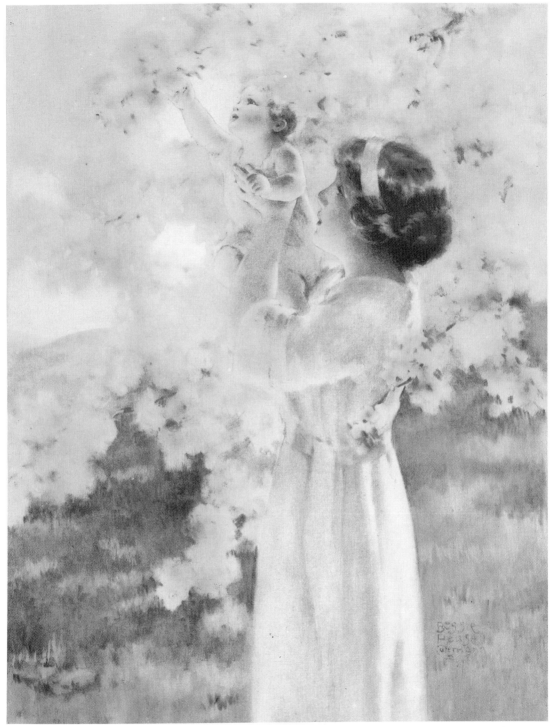

FIG. 5-102 "Blossom
Time" No. 653, April 20,
1917. (Author's collection)

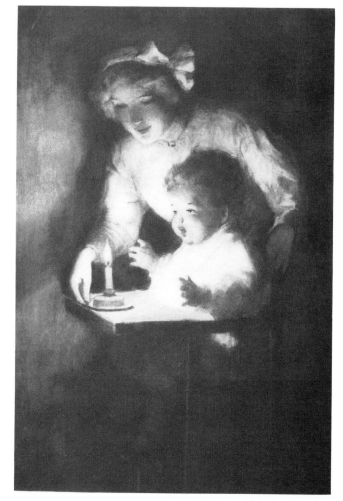

FIG. 5–104 "Mermaid
Pearls" (no number issued)
May 28, 1915. Print was
unsigned and copyrighted
by Gutman & Gutman
(sic), N.Y. A similar sub-
ject of a baby mermaid was
found on a German lan-
guage postcard and signed
"B. Gutmann," characteris-
tic of the signature of
Bernhard Gutmann, the
brother-in-law of Bessie
Pease Gutmann. The trans-
lation of the card gave it
the title of "Waterlily;"
however, it is speculated
that the image was actually
"The Baby of the Lake" is-
sued April 26, 1906. (Col-
lection of Mary and Joseph
Connors)

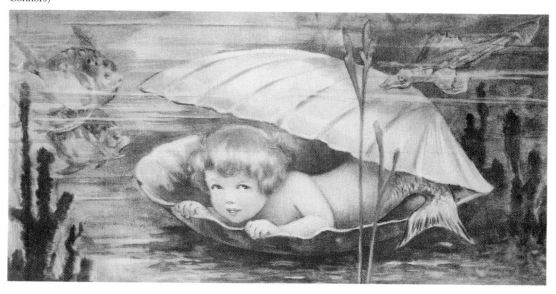

FIG. 5-105 "Verdict—Love for Life" No. 113, April 10, 1909. (Author's collection)

Cupid's Reflection.

FIG. 5-106 "Cupid's Reflection" No. 602, March 25, 1909. (Author's collection)

SPEEDING

FIG. 5–108 "Speeding"
No. 637, April 1, 1914.
(Collection of Mary and
Joseph Connors)

6 All for a One Cent Stamp— Postcard Art

BECAUSE SHE WAS a disciplined artist and maintained a regular work schedule, Bessie Pease Gutmann was able to extend her talents into many years of marketing. The postcard industry was at its peak in the early 1900s and many of the pictures executed by her were naturals for postcard images. To the cartaphilian the seventy-plus postcards issued and bearing the signature of Bessie Pease Gutmann or Bessie Collins Pease represent an exciting challenge. The quality of reproduction and scarcity of her cards have resulted in them ranking near the top of the most sought after in the postcard collecting hobby.

The artwork utilized for her postcards was characterized by muted color tones and light backgrounds. The broad range of subjects used (babies, children, teen-agers, and adults of all ages) clearly illustrates that she was an accomplished artist. Many of her cards, produced in series but not marketed as such, caused considerable excitement when released (Figs. 6-1–6-5).

Her five-card series, "Events in a Woman's Life" (1911), rivaled a similar series by Harrison Fisher issued that same year. Unlike Fisher's, her figures were produced with mostly white backgrounds which caused the colorful images to predominate. The six-card "Young Girls" (1911) series featuring the first names of her daughters, nieces, and children of family friends (Alice, Lucille, Dorothy, Margaret, Virginia, and Betty) are charming, delightful, and sensitive, as are the series "Fancy Women" (1911), "Babies Sitting" (1913), "Mothers with Babies" (1913), "Young Women" (1911), and "The Five Senses" (1909). Some of the images used in the "Babies Sitting" and "Mothers with Babies" series had previously appeared as illustrations in the 1908 book *Our Baby's Early Days* published by Best & Co.

The series on the five senses was so popular that the New York firm of Furst Brothers & Company placed these cards in a singly imprinted frame and marketed them in the department stores of New York City and Boston. The same was known to have been done with the "Events in a Woman's Life" series which was marketed by Reinthal & Newman in a brown oval tin frame with an imprinted mat.

The artist prepared many of her illustrations specifically with the postcard

FIG. 6–1 "Events in a Woman's Life" (1300–1304), l to r: The Baby (1300), Off for School (1301), The Debutante (1302), The Bride (1303), The Mother (1304). (Panels in Figs. 6-1–6-5 from the collection of Susan and Warren Wisseman)

FIG. 6–2 "Young Girls" (800–805), l to r: Margaret (800), Betty (801), Virginia (802), Alice (803), Lucille (804), Dorothy (805).

in mind and did not simply depend on the reproduction of previously issued book or magazine illustrations and art prints. Unlike many of her contemporaries, she produced illustrations for postcards which avoided the social issues of the day. Her work was highly sought as a means of escaping the preponderance of issue-oriented cards. Her images were painted to delight the buyer and the recipient. It was a tribute to her artistry that the popularity of her postcards today is because of the timelessness of her art subjects. Few people can look into the face of the young lady in the wide-brimmed hat of "I Wish You Were Here" (1911), or at the young mother cradling her new born in "In Slumberland" (1913), without the feeling that this was truly the gentle world of another time. In commenting on two of her early cards, "Falling Out" and "Making Up" (1909), a writer noted that they exhibited "a fine sense of design and juxtaposition of color."[71]

Her cards were as popular in Europe as in the United States and many examples of pirated printed cards have been discovered. In fact, some of the European cards featured artwork that was never issued as postcards. There is

FIG. 6–3 "Fancy Women" (500–505), l to r: Rosebuds (500), Senorita (501), Waiting (502), Daydreams (503), Poppies (504), I Wish You Were Here (505).

FIG. 6–4 "Mothers with Babies " (1000–1004), l to r: Sunshine (1000), I Love to be Loved by a Baby (1001), Baby Mine (1002), The Sweetest Joy (1003), In Slumberland (1004).

no record to determine just how many cards were published outside of the United States but attesting to the interest in her postcard subjects are the number of foreign language imprints and overprints that have turned up.

At least ten different printing firms produced the postcards for Gutmann & Gutmann with Reinthal & Newman in the United States and Charles A. Hauff and The Alphasa Publishing Company in London being the principal printers. The cards were the standard $3\frac{1}{2}'' \times 5\frac{1}{2}''$ with a divided back. The illustrations were of excellent quality lithography and some have been identified as being hand tinted.

The five-year period (1909–1913) that Bessie Pease Gutmann cards were marketed was highly profitable for Gutmann & Gutmann. Foreign and domestic distributors were clamoring for the cards and in 1911 the company reached its sales peak, as did the entire postcard industry. With the passage of the Payne-Aldrich Act in 1909, which imposed a high import tariff on the postcards that Gutmann & Gutmann were having printed in Germany and England, and the advent of World War I which totally eliminated the printing and importing of postcards from the world's prinicpal supplier, Germany, the "golden age" of the postcard industry had passed.

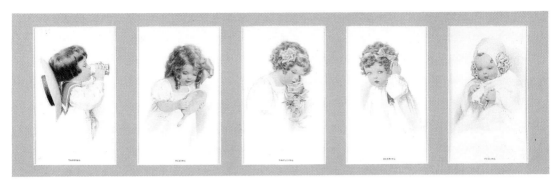

FIG. 6-5 "The Five Senses" (1200-1204), l to r: Tasting (1200), Seeing (1201), Smelling (1202), Hearing (1203), Feeling (1204).

7 The Other Side—
Greeting Cards, Sculpture, Jewelry,
and Unpublished Works

GUTMANN WAS ALWAYS improving her skills and experimenting with different media, as well as different art forms. Example after example of her experimental activities were found after she passed away. These examples not only attest to her versatile talents but also to the fact that self-improvement was an innate characteristic of hers. Sketch books containing hundreds of examples of scenes sketched on her trips abroad and landscapes of the Florida Keys; a sculptured form; etchings on isinglass; homemade greeting cards that she produced, handling all of the etching procedures herself; still life in pastels, oils, temperas, and watercolors; the designing of elaborate settings for semiprecious gem stones; the designing of book plates—all of these, and probably more, were indicative of enormous talents, an inquisitive mind, and an insatiable appetite for experimenting with different art forms.

Greeting Cards
Throughout the 1920s and into the 1930s, she was an active member of The Art Centre of the Oranges (New Jersey) who participated as a student in many of the instructional programs. The classes in advanced etching conducted by instructor-etcher Rowland C. Lewis were a delight to her and she exhibited her class work as part of the program. No doubt that her instruction in these classes resulted in her preparing her own Christmas cards.

From 1920 to the 1930s, Mrs. Gutmann prepared greeting cards that were sent to a small number of friends. Examples of these cards are elusive to the collector and, because she acted as her own etcher and colorist, are probably as close as most collectors will get to original work. Using either a copper or glass plate, she inscribed images from original artwork and then impressed them on handmade etching paper bearing such watermarks as "Georgian," "France," "Amor Butten," and "Lanweave." These imported paper cards were all double or French-folded panel cards on handmade, high quality laid watermarked paper stock with deckled edges. Most of the cards,

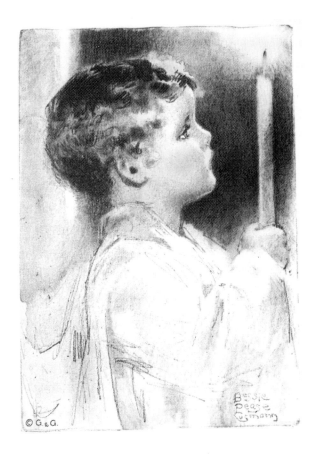

FIG. 7–1 Christmas Card #9. (Author's collection)

when completed, had a small etched illustration on the outside front within an embossed panel, such as Noah's Ark with giraffe, baby with winter bonnet, child feeding winter birds, burning candle in old-fashioned holder, three candles with pine tree background, sprig of holly, small angel, three hanging stockings, and others (Figs. 7-1 and 7-2).

The greeting card etchings are superb examples of the versatility of her artistry. Each card, including the front panel vignettes, were hand-tinted, by the artist, with watercolors. The illustrations were signed "BPG" or "Bessie Pease Gutmann" and they all had the identical message: "Mr. and Mrs. Hellmuth Gutmann extend to you their best wishes for a Happy Christmas and Joyous New Year." The cards were tied with a red or green silk ribbon and bow and had folded dimensions of $4'' \times 6''$ and $5'' \times 7\frac{1}{2}''$.

One of the cards featured a portrait of a young girl (Alice, her oldest daughter) with dark hair, wearing a winter cloche hat with a feather in it. A card showing a winter rooftop scene with a stork in the foreground and a cathedral in the background may have been intended as a New Year's card, however, it was probably never sent because of the misspelling of their last name as Gutmans. The main illustration in each of the twenty-two cards that have been discovered was that of a Gutmann baby or young child. The same

FIG. 7-2 Christmas
Card #10. (Author's col-
lection)

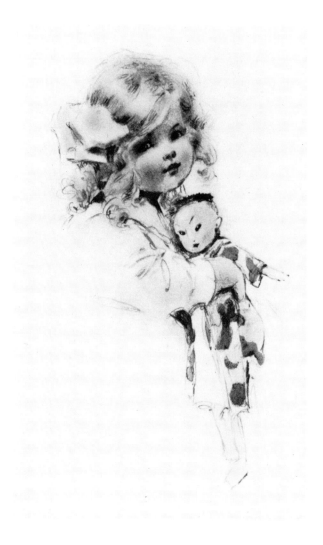

sensitivity and realistic modeling of her subjects are found here as in her
prints. Using only watercolor in soft shades, she conveys the message of
peace and love to the recipient.

There is evidence that the Gutmann & Gutmann firm may have been
considering entering the greeting card field, for several examples of prelimi-
nary sketches have been discovered in the artist's work portfolio. Unique
among these is the unfinished Valentine card (showing the artist's legend of
"Valentine Greetings") which was done in pencil and watercolor and
depicts a typical Gutmann baby and mother in a colorful floral setting.

Sculpture

The fact that Bessie Pease Gutmann had any desire to sculpt and, if so, that
she ever did a piece was a well-kept secret until a finished sculptured head
was accidently discovered in her studio closet. The sculptured head was of
Lucille, her second child, done when she was a pre-schooler (Fig. 7-3).

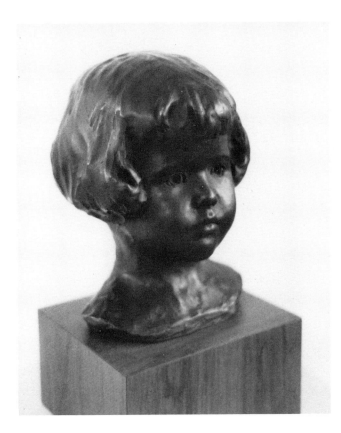

FIG. 7–3 Sculptured bust of Lucille, Bessie Pease Gutmann's second child, done in 1913. Found in the studio closet after the artist's death in 1960. Cast in epoxy in 1972. (Courtesy of Lucille and William Horrocks)

Using plasticine as her modeling material, she completed a charmingly delightful little face with rounded cheeks, inquiring eyes, and a slightly pouting mouth. Considerable detail is shown in the sculpturing work right down to strands of hair which wreathed the tiny cherubic face. She may not have been pleased with her work, or she may have intended to go back to it at another time. In any case, it was put in her closet where it was discovered years later by Lucille. Since then the head has been "bronzed" with a mixture of Venus 61 bronze powder and shellac, and set on a parquet block of wood. It stands as a testament to the many talents of the artist.

Jewelry

On one of their several trips to the Middle East, the Gutmanns spent some time in Egypt. On the way to board their ship in the port of Cairo, they happened through the bazaars. While looking at jewelry they saw an unusually large zircon stone of beautiful color which Mrs. Gutmann admired. As they hurried to board the ship, Hellmuth decided to go back and purchase the stone for his wife. The stone, of thumbnail size, was the delight of Mrs. Gutmann who began to sketch setting designs for it in their hotel room in Berlin. She eventually came up with a design that was to her liking and the stone was set in a platinum necklace by a Berlin jeweler. She wore it often and gave friends photographs of herself, which were taken for

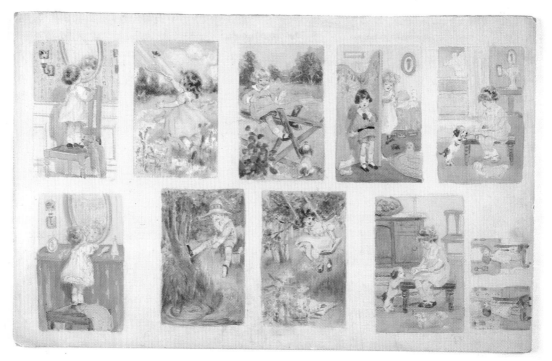

FIG. 7-4 Original sketch board. Some of the images were the size of postage stamps. (Collection of Mrs. John C. Gutmann, Sr.)

publicity stills, wearing the necklace. The "Cairo" zircon necklace figured prominently in her will written in June, 1950.

Unpublished Works

Like all of us, Bessie Pease Gutmann relaxed by doing things she considered fun—still lifes, portraits, landscapes and seascapes. Even after she had ceased painting for purposes of publication she continued to paint her "escape art." The number of individual works that she did for "relaxation" numbered in the hundreds (Fig. 7-4). Working mostly with oils, she completed (and signed) beautiful works of flower arrangements from her husband's gardens (Figs. 7-5 and 7-6); ginger jars, vases, images of Pierrot, oriental motifs (Figs. 7-7 and 7-8); and fruit. Her landscapes and seascapes featured scenes from the Florida Keys and from trips to Europe. Etchings of cats and dogs; portraits of Lucille, Alice, and other children; and a striking Mexican style Madonna and Child done in pastel on brown paper stock (Fig. 7-9) provided her with a change of pace. Most of her work in oils has considerable resemblance to the work of the post-impressionists such as Bernhard Gutmann, Edward Potthast, and Robert Henri.

All of these unpublished works were never intended to be marketed and were given by the artist to friends, models, or remained with the family. An examination of her work portfolios and sketch pads reveals that literally hundreds of quick pencil, charcoal, and watercolor drawings were intended for future reference, however, they remained in their unfinished state. The images are indeed the happy, loving, and caring creations of Bessie Pease Gutmann. The little fellow proudly walking to school with an apple for his

FIG. 7–5 "Hydrangeas" in green vase on table, oil on canvas, 18″ × 24″. (Collection of Mrs. John C. Gutmann, Sr.)

FIG. 7–6 "Garden Flowers," oil on board, 24″ × 18″. Exhibited Shenck Galleries, Newark, New Jersey, c. 1940. Unpublished. (Collection of Mrs. John C. Gutmann, Sr.)

FIG. 7–7 "An Oriental Trio," Ming dynasty bulbous jar, a Chinese ginger jar and pewter dish on red and black silk runner, oil on canvas, 20″ × 16″. Exhibited at Kresge's Department Store Gallery, Newark, New Jersey, c. 1940. Unpublished. (Collection of Jennifer and John Gutmann)

FIG. 7–8 Still life. Unpublished, oil on canvas, 16″ × 20″, Ming vase, peacock vase and brass coaster on a blue/green silk Chinese table runner. (Collection of Mrs. John C. Gutmann, Sr.)

FIG. 7–9 "Madonna and Child" in mostly blue and white pastel over brown construction paper, 18″ × 23″ vertical. Unpublished. (Collection of Carol Gutmann Brown)

teacher, the sweet child holding out a fresh picked flower to you, the mother mermaid and her child, the little fellow and his puppy dog (Figs. 7-10– 7-14), the mother and child gazing at a frog, and the hundreds of sketches of babies, children, and adults all remain unfinished, never to be shared with an admiring public (Figs. 7-15 – 7-18). One of these still lifes was found in a trash can containing house-cleaning items in a New Jersey seashore town in 1986. I purchased the work for a small sum after noting the signature of Bessie Pease Gutmann on this oxidized oil on canvas.

FIG. 7–10 "Boy with Apple," original, unpublished watercolor, 12″ × 16″. (Collection of Mrs. John C. Gutmann, Sr.)

FIG. 7–11 "Girl with Flower," original, unpublished watercolor over charcoal, 9″ × 12″. (Collection of Mrs. John C. Gutmann, Sr.)

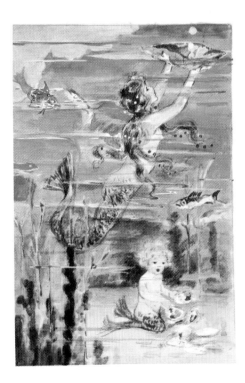

FIG. 7-12 "The Mermaid & Daughter" watercolor over pencil, $5\frac{1}{2}''$ × 8". Unpublished. (Collection of Mrs. John C. Gutmann, Sr.)

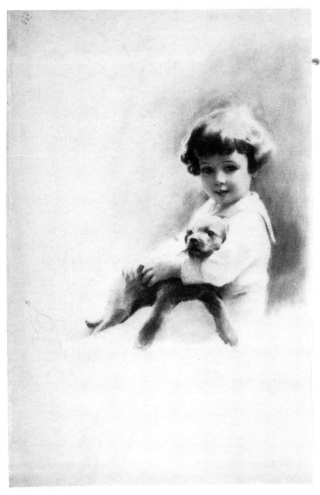

FIG. 7-13 "Boy with Puppy" charcoal and ink wash, 12" × 15". Unpublished. (Collection of Mrs. John C. Gutmann, Sr.)

159

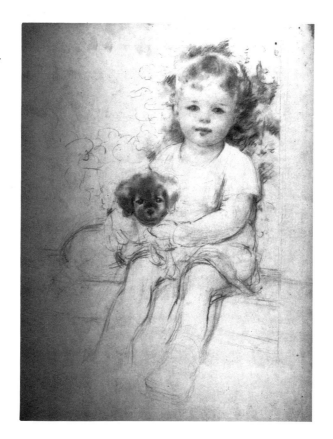

FIG. 7–14 "Boy and Puppy," original, unpublished charcoal sketch, 18″ × 26″. (Collection of Mrs. John C. Gutmann, Sr.)

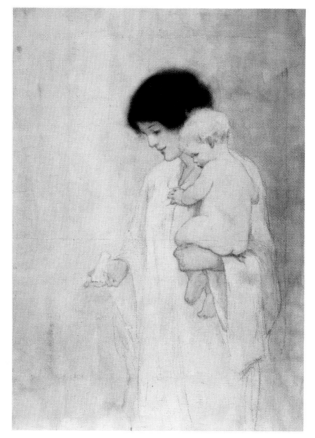

FIG. 7–15 "Mother and Child with Toy," oil on canvas, 19″ × 25″. Unpublished. (Collection of Mrs. John C. Gutmann, Sr.)

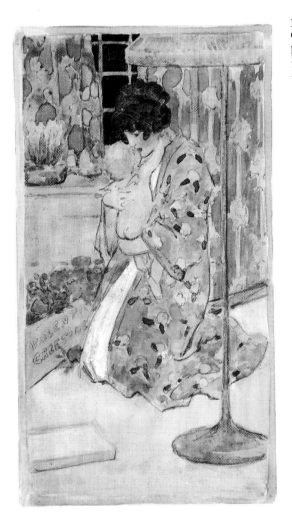

FIG. 7–16 "Valentine Greetings," watercolor over pencil, 4″ × 7″. Unpublished. (Collection of Mrs. John C. Gutmann, Sr.)

FIG. 7–17 Pencil sketch of young child, 1″ × 1½″. Unpublished. (Collection of Mrs. John C. Gutmann, Sr.)

The Past is Prologue

8 🖋

PREPARATION FOR and the advent of World War II in the early 1940s brought the fine arts print industry to a virtual standstill. Having successfully weathered the Great Depression, Gutmann & Gutmann now faced the greatest of its many challenges. Shortages of quality paper, reduction in the work force, the redirection of certain elements in printing inks to the war effort, and a public whose interests were redirected and geared for an all out effort in support of the war, all forced the firm to curtail its activities. It would have seemed the coup de grace had been administered to the business that had achieved so much success and had given so much pleasure in the early decades of the century. Interest in Gutmann babies had been supplanted by the antithesis of gentleness and innocence . . . war.

The death of Hellmuth in 1948, the rapid deterioration of her eyesight, and an unsuccessful attempt to revive the business of the firm in the early 1950s were sufficient causes for the firm to be acquired by loyal worker and family friend, Albert Immergut. The new firm of Gutmann & Gutmann issued only four new copyrighted Gutmann prints from 1950 to 1952. The last three art prints to carry the signature of Bessie Pease Gutmann were "My Baby" (1952), "Popularity has its Disadvantages" (1952), and "Nitey-Nite" (1952). The latter print was the same subject as the 1938 print, "On the Up and Up," except that instead of rompers the littler fellow is now wearing pajamas.

The firm struggled over the next few years to remain in business, and then it happened. In the early 1970s, a phenomenon occurred reminiscent of the clamor for Gutmann prints in the early 1900s. Today, there is an amazing revival of interest in the artwork of Bessie Pease Gutmann, to the extent that a national organization has been formed to celebrate her art form and to gain recognition for her achievements. A regular newspaper is issued which carries news related to Bessie Pease Gutmann and her art. A new generation of admirers and collectors are experiencing the joys and pleasures that her art gives. The collectible world is featuring items that, undreamed of in the early years, are making appearances through a careful program of approval and quality control. The Bessie Pease Gutmann purist, the collector of original prints, postcards, covers, illustrated prints, and other memorabilia, have

banded together with cult-like enthusiasm and travel all over the country seeking out her work at auctions, shows, outdoor markets, and garage sales.

In May 1988, the historical New Jersey community of Mount Holly and the Mount Holly Historical Society conducted special ceremonies honoring their famous artist. A special memorial plaque in the name of Bessie Pease Gutmann was placed on the home where she spent much of her childhood. This exciting resurgence for the art of Bessie Pease Gutmann came as no surprise to her admirers.

And so it was on a quiet day that I stood in the tranquil setting of the Mount Holly Cemetery and looked down at a simply inscribed stone which read, "BESSIE PEASE GUTMANN 1876–1960" . . . and I was angry. Five years of researching this great artist and I had found no memorial exhibits for her, no tributes, not a single line of obituary notice for this wonderful woman who had spent a lifetime giving happiness and joy to so many. . . the one who was called "the greatest of all children's artists," "America's most famous baby artist," "one of America's foremost illustrators of children and the gentle world they inhabit," and so on. My anger subsided and completely melted as I realized that this simple headstone reflected the way Bessie Pease Gutmann had lived her life. She chose to live unobtrusively so that her art, not she, would be remembered. She never sought recognition and considered the road-blocks that society placed before her a small inconvenience as she pursued her life and career.

And then I finally became aware that this warm and loving person had transferred her own gentleness onto her canvas for all of us to enjoy. We see the human attributes of love, freshness, warmth, sincerity, and youthful innocence in all her subjects. Certainly the passage of time has not eroded her legacy.

Bessie Peace Gutmann's art has the ability to take each of us by the hand for a brief and beautiful moment and lead us *into a gentle world*.

Notes

1. Francis A. Lancelot, *The Girl's Realm,* December 1908, p. 129.
2. *Pictorial Review,* March 1913, p. 3.
3. *American Home,* September 1975, p. 17.
4. Ann Barton Brown, *Charlotte Harding; An Illustrator in Philadelphia,* p. 15.
5. S. Michael Schnessel, *Jessie Willcox Smith,* p. 9.
6. Christine Jones Huber, *The Pennsylvania Academy and Its Women,* pp. 19–20.
7. Lancelot, p. 129.
8. Interview, Alice Gutmann Smith, August 11, 1983.
9. Interview, Alice Gutmann Smith, June 10, 1985.
10. Lancelot, p. 132.
11. *Picture & Gift Journal,* May 1927, p. 8.
12. Interview, Alice Gutmann Smith, June 10, 1985.
13. Debbie Alterman to Dr. Victor J. W. Christie, January 17, 1984.
14. Theodore C. Knauff, *An Experiment in Training for the Useful and the Beautiful,* p. 87.
15. Knauff, p. 89.
16. Debbie Alterman (Library Director, Moore College of Art) to Dr. Victor J. W. Christie, February 8, 1984.
17. Interview, Lucille Gutmann Horrocks, July 11, 1983.
18. Interview, Alice Gutmann Smith, May 27, 1985.
19. *Mount Holly Herald,* undated news article.
20. *Mount Holly Herald,* "Mount Holly Artist Honored," undated.
21. Regina Armstrong, "Representative Women Illustrators: The Child Interpreters," *The Critic* (1900): 417.
22. Interview, Alice Gutmann Smith, August 11, 1983.
23. Lawrence Campbell (The Art Students League of New York) to Dr. Victor J. W. Christie, May 5, 1988.
24. Mrs. Albert Immergut (partner in the firm of Gutmann & Gutmann) to Carol E. Coon (Reference Librarian, Bay Area Reference Center, San Francisco Public Library), February 6, 1976.
25. Gene Mitchell, *The Subject Was Children: The Art of Jessie Willcox Smith,* p. 2.
26. Interview, John Collins Gutmann Sr., September 17, 1983.
27. *Mount Holly Herald,* July 16, 1906.
28. Interview, Lucille Gutmann Horrocks, August 11, 1983.
29. Lancelot, p. 129.
30. Mary Jane Rutledge, *Newark Sunday Call,* September 30, 1934, p. 15.

31. Interview, John Collins Gutmann Sr., September 19, 1985.
32. Rutledge, p. 15.
33. Lancelot, p. 129.
34. *The Orlando Times,* August 16, 1927.
35. Interviews: John Collins Gutmann Sr., Lucille Gutmann Horrocks, Alice Gutmann Smith.
36. Lancelot, p. 130.
37. Interview, Alice Gutmann Smith, August 27, 1983.
38. Ibid.
39. Rutledge, p. 15.
40. Interview, Alice Gutmann Smith, August 27, 1983.
41. Marcy Levitch, *Essex Journal,* September 2, 1982, p. 3.
42. Frances W. Marshall, *Philadelphia Public Ledger,* December 15, 1912, p. 1.
43. Rutledge, p. 15.
44. *Woman's Home Companion,* August 1907.
45. *St. Nicholas Magazine,* December 1914, back of front cover.
46. *Woman's Home Companion,* August 1907, p. 1.
47. *Pictorial Review,* March 1913, p. 1.
48. *Pictorial Review,* March 1915.
49. Ibid.
50. *St. Nicholas Magazine,* January 1910, p. 13.
51. Interview, Alice Gutmann Smith, April 2, 1989.
52. Lancelot, p. 130.
53. Brooklyn Museum, *Curator's Choice: The American Watercolor Movement 1860–1900,* New York, March 1–14, 1988.
54. Peggy Morris, ed., *American Illustrator's Newsletter,* Fall 1985, pp. 3, 4.
55. *Picture & Gift Journal,* May 1927, p. 8.
56. Lancelot, pp. 132–133.
57. Ibid.
58. *Picture & Gift Journal,* May 1927, p. 8.
59. Interview, Alice Gutmann Smith, April 2, 1989.
60. *Picture & Gift Journal,* May 1927, p. 8.
61. *The Delineator,* August 1908, p. 245.
62. William Innes Homer, *Robert Henri and His Circle,* p. 72.
63. Rutledge, p. 15.
64. Ibid.
65. Lancelot, p. 130.
66. Ibid.
67. Interview, John Collins Gutmann Sr., September 19, 1985.
68. Lancelot, p. 134.
69. Ibid.
70. Alice Barber Stephens, *Woman's Progress,* November 1893, p. 49.
71. Dorothy B. Ryan, *Picture Postcards in the United States 1893–1918,* p. 203.
72. W. E. Craven & Co. to Gutmann & Gutmann, May 17, 1917.

Appendix

CHRONOLOGY

1876	April 8. Born in Philadelphia to Horace Collins Pease and Margaretta Young Pease. The fourth of five surviving children (four daughters and one son).
1882–1893	Attended public schools in Mount Holly (the Brainerd School and Mount Holly High School), New Jersey where she won several awards in art competitions.
1893–1894	Attended the Philadelphia School of Design for Women where she studied under Robert Henri and Alice Barber Stephens.
1896–1898	Studied at the New York School of Art where one of her instructors was William Merritt Chase.
1899	Received first commission work for a peace jubilee banquet for the ladies of President William McKinley's party in Atlanta, Georgia.
1899–1901	Studied at the Art Students League of New York under the tutelage of Kenyon Cox, Joseph DeCamp, Walter Appleton Clark, Arthur W. Dow, Frederick Dielman, and H. Siddons Mowbray.
1903	Employed as an illustrator/artist by the New York firm of Gutmann & Gutmann. Her initial work was in illustrating advertisements.
1904–1905	Earliest published work for *St. Nicholas Magazine* was of an illustrated poem, "Smiling, Slip Asleep," by Alex Jeffrey (October 1904). Two additional poetry illustrations in 1905, "On The Hillside," by F. S. Gardiner and "Brave Annabel Lou," by Clara Odell Lyon.
	Commissioned by the Dodge Publishing Company of New York to illustrate three books by the poet/author Edmund Vance Cooke.
	First major illustrating commission by the Dodge Publishing Company of New York to illustrate Robert Louis Stevenson's *A Child's Garden of Verses*, which required twenty-four full color plates (1905).
1906	July 14. Married Hellmuth Gutmann (born in Hamburg, Germany, April 26, 1867) in Mount Holly, New Jersey. Witnesses were Hellmuth's brother Bernhard and her father, Horace Collins Pease. Officiating was the Rev. Charles J. Young.
	First magazine cover illustration appears in the December issue of *Pearson's Magazine*.

1907	Alice King Gutmann born October 24.
	Cover illustration "Bubbles" chosen for the *Woman's Home Companion* 1908 Baby Calendar.
	Commissioned by the Brown & Bigielow Company of St. Paul, Minnesota, to create thirteen calendar art subjects.
	Received a commission from the Dodge Publishing Company to illustrate Lewis Carroll's *Alice's Adventures in Wonderland*.
	Gutmann & Gutmann issued her first successful paired art prints, "Falling out" and "Making Up."
1908	Moved into home/studio in South Orange, New Jersey.
1909	Commissioned by Robert Chapman Company of New York to prepare general artwork of children at play for book illustrations.
	Lucille Gutmann born.
1910	The Wells and Richardson Company of Burlington, Vermont, offered a commission to prepare artwork for a store hanging tin for their Diamond Dye product and "A Busy Day in Dollville" is produced.
1913	Prepared four artworks for Swift & Company, Chicago, Illinois, and the Swift's Premium Nature Study Calendar for 1915 resulted.
1914	Received the "Artist of the Year" award in the annual reader contest of *Pictorial Review* magazine.
1916	Completed her most famous work, "A Little Bit of Heaven," which sold millions of prints throughout the world. The model was her second daughter Lucille.
	John Gutmann born.
1918	Completed "Angel's Kin" which was renamed "Awakening" and sold as the second half of a pair with "A Little Bit of Heaven."
1925	Purchased summer home/studio in Island Heights, New Jersey.
1935–1936	Completed "In Disgrace" and "The Reward" which became record sellers as matched art prints.
1947	Ceased producing art for publication due to failing eyesight.
1948	April 26. Hellmuth Gutmann died. Gutmann & Gutmann changed ownership soon after.
1960	September 29. Died at the age of eighty-four in Centerport (County of Suffolk), New York, and interred in the Mount Holly (NJ) Cemetery.
1988	May 21. On Mount Holly Day, the Mount Holly Historical Society dedicated a plaque on the former residence (34 Brainerd Street) of its famous citizen, Bessie Collins Pease Gutmann.

ILLUSTRATED BOOKS

Bessie Pease Gutmann's book illustrating work was all accomplished within the first decade of the century at a time when little or no records were maintained. Consequently, new discoveries of her work are constantly being reported. The following alphabetical listing includes the illustrations that were, for the most part, only book plates and rarely appeared as prints. The publications of the Hurst Publishing Company are grouped under a single heading since, to date, only four different illustrations by Bessie Pease Gutmann have been reported as appearing in the Hurst books.

Alice's Adventures in Wonderland by Lewis Carroll. Dodge Publishing Company

(New York) 1907 (ten full-page color illustrations and numerous black and white illustrations). This book went into a fifth printing and was published by George G. Harrap and Company, Ltd. (London) 1920; J. Cookes & Company, Ltd. (London) 1933; The Longmeadow Press (a reprint edition copyrighted by Dilithium Press, Ltd. as part of their Children's Classic Division) 1988:

"The rabbit actually took a watch out of its pocket"
"We beg your acceptance of this elegant thimble"
"I hope I sha'n't grow anymore"
"Her eyes met those of a large blue caterpillar"
"It was opened by another footman"
"Then he dipped it into his cup of tea"
"You sha'n't be beheaded"
"I don't see how he can ever finish if he doesn't begin"
"The Gryphon only answered 'Come on' and ran the faster"
"Where shall I begin, please your majesty?"

The Biography of Our Baby by Edmund Vance Cooke, Dodge Publishing Company (New York) 1906:
"The First Lesson"
Baby lying on pillow
"This is a record of the child-life of. . ."
"Be it known to all by these presents. . ."
Baby's Weight
Baby's Presents
The First Photograph
"Our Baby's First Outing was taken. . ."
Baby's First Short Clothes
"Our Baby's Shoes"
Baby's First Tooth
"A Record of Our Baby's Sayings"
This lock of hair
This is the day
Mother reaching for baby in crib
Baby's First Steps
Baby's Height
"Our Baby's Playmates"
Writing At Various Ages
Red Letter Days

Book of the Bride, M. A. Donahue Company (Chicago) 1913:
Frontispiece, "To Love and To Cherish" #615

A Child's Garden of Verses by Robert Louis Stevenson, Dodge Publishing Company (New York) 1905:
Frontispiece, untitled (girl with cow)
"A Thought"
"At the Sea-side"
"Rain"
"Pirate Story"
"Foreign Lands"
"Auntie's Skirts"
"A Good Play"
"The Land of Counterpane"
"My Shadow"

Girl picking flowers
"My Bed is a Boat"
"Time to Rise"
Boy on a sled coming down hill
"Northwest Passage"
"Shadow March"
"In Port"
"My Treasures"
"Block City"
"Garden Days"
"The Gardener"
Girl on stool, boy next to her

Chronicles of the Little Tot by Edmund Vance Cooke, Dodge Publishing Company (New York) 1905:
"A Christmas Kid"
"The Intruder"
"The Baby on the Floor"
"The Childhood of Spring"
"The Moo-Cow-Moo"
"Over the Hills and Far Away"

The Diary of a Mouse by Edith Dunham, Dodge Publishing Company (New York) 1907 (twenty-five black and orange illustrations).

The Expressive Readers Series by James Baldwin & Ida C. Bender, American Book Company (New York) 1911 (third grade reader with one black and white illustration for the story *The Cricket on the Hearth*).

From Sioux to Susan by Agnes McClelland Dalton, The Century Company (New York) 1905 (this book of 342 pages and twenty-two black and white illustrations appeared as a serial story in *St. Nicholas Magazine* during 1904–1905):
"She enoys a drive with her 'Parsley-Girl.' "
"Around and around they went."
"Sue."
"She was cutting out a waist for Benny."
"I've changed my name to S-I-O-U-X."
"You see, I wanted it to be just a secret between us two."
"Betty, the proper, sat quiet and demure."
"And doing up her hair with one pin, Virginia rushed to the window."
"Mrs. Marshall was standing in the doorway."
" 'What's the matter, Sue?' faltered Davie."
"Just wait till I get a dust of powder on my nose."
"I could just see Sue Robert's eyes dance when she opened it."
" 'I never felt so funny in my life,' whispered Sue."
"Virginia and Sue opened their door at the first tap of the breakfast bell."
"The gay Queen of the screech owls sat upon her throne."
"They had tacked up the Indian prints."
"Sue was never so frightened in her life."
"Perhaps it will come out all right."
"The day Virginia's belated South American Christmas gifts arrived."
"The music room was all abuzz when an Indian in a gay blanket shuffled in."
"I was hiding there this morning."
" 'Tell her, Thad,' whispered Virginia."

Our Baby's Early Days: A Chronicle of Many Happy Hours, Best & Company (New York) 1908. (The major color illustrations were prepared by Bessie Pease Gutmann

with page decorations by Meta Morris Grimball. The printing and color lithography for this work was done by the Quadri Company of New York City and was superior to the color reproductions of the day. All of the illustrations by Bessie Pease Gutmann that appeared in this limited edition book were to appear at a later date as postcards and art prints.)

"His Majesty"
"Dessert"
"I Love to be Loved by a Baby"
"All is Vanity"
"Come Play with Me"
"The Sweetest Joy"

Through The Looking Glass: And What Alice Found There by Lewis Carroll, Dodge Publishing Company (New York) 1909:

"It was a golden crown"
"Alice was sitting in the great arm-chair, half asleep"
" 'Now! Now!' cried the Queen. 'Faster! Faster!' "
"A sudden look of alarm came into its beautiful eyes"
"He called it a helmet, though it looked like a sauce pan"
"The little arms were plunged in elbow deep"
" 'It's very provoking to be called an egg—very.' "
"Alice seated herself with the great dish on her knees"
" 'What is it now?' said the frog."
"And then all sorts of things happened."

Told to the Little Tot by Edmund Vance Cooke, Dodge Publishing Company (New York) 1906:

"The Story Book Boy"
"How Miss Tabitha Cat Taught School"
"The Mamma Girl and the Sugar Doll"
"Trixy and the Tick Tick"
"Down the King's Chimney"
"The Snow Man and His Baby"
"Santa Claus on a Strike"
"Going to Meet Christmas"
"How the Man Mite Saved Christmas"

Note: Books published by Hurst and Company (New York) from 1909–1915 used illustrations which had been purchased from a print broker, Robert Chapman & Company. Four prints prepared by Bessie Pease Gutmann have been reported as having been used singly or paired in the following Hurst books: *Childhood Days* (1912), *Christmas Tree Land* (1912), *Golden Hours* (1912), *How Mama Used to Play* (1912), *Our Boys and Girls Story Book* (1912), *Our Darling's Book of Dolls* (1912), *Our Darling's Book of Play* (1912), *Prattles for Our Boys and Girls* (1912), *Vacation Land* (1912), and *A Visit to the Farm* (1912). Prints reported are:

"Crowning the May Queen"
"Preparing for the Seashore"
"Serving Thanksgiving Dinner"
"Playing House"

MAGAZINE COVERS

The research related to the artwork of Bessie Pease Gutmann was consistently hampered by the absence of annotated records, thus a heavy reliance was based on collector's records, the records in the Library of Congress, and simple discovery. It is

estimated that she did over twenty covers for major magazines and received competitive awards for her efforts but when the research record is closed it may indicate that she actually did double that number. The listing that follows is by periodical and if a work was one that eventually appeared in art print form the publisher's number is shown:

Pictorial Review (11″ × 16″)

June 1909	"Buds" #603
March 1913	"Our Alarm Clock" #626
March 1914	"Pack Up Your Troubles in Your Old Kit Bag, and Smile, Smile, Smile" #662
May 1915	"Double Blessing" #643 & #232
December 1915	"The Christmas Wreath"
December 1916	Girl with winter hat carrying Christmas packages and waving with her right hand
March 1917	"An Anxious Moment" #711
May 1917	Girl in blossoming tree
December 1917	Same illustration as Christmas Card #15
January 1918	"Chums" #665 & #263
January 1922	Girl with angora-like knit hat and coat (full face)

McCall's (8″ × 10¾″):

May 1910 Girl's head with old-fashioned pink sunbonnet
May 1912 "Bubbles"

The Metropolitan (8⅛″ × 11″):

January 1911 "Sweet Sixteen" ("Rosebud" postcard)

Woman's Home Companion (11¼″ × 16⅛″):

August 1907 "Bubbles"

Pearson's (6½″ × 9½″):

December 1906 Girl holding armful of dolls and toys (two covers)
April 1910 "Easter Boy" #125

The Chicago Sunday Tribune [The Monthly Magazine section] (10¼″ × 13¼″):

July 10, 1910 "The Anxious Mother" #214
August 14, 1910 "Merely a Man" #218

The Circle and Success Magazine (11″ × 16″):

November 1907 Not identified
October 1912 Man and woman looking at a lighted Hallowe'en pumpkin

The Washington Post (9½″ × 12″):

July 10, 1910 "Accidents Will Happen" #30

CALENDAR ILLUSTRATIONS

The demand by calendar companies such as The Osborne Company, Joseph C. Knapp Company, and the Brown & Bigelow Company for original art in the early 1900s was insatiable. Many artists began their careers by providing these businesses with colorful illustrations that were primarily single line renderings and, for the most part, easily forgotten. Bessie Pease Gutmann was no exception to this and produced a considerable amount of work for the calendar industry. Unfortunately, some very fine early work of hers has disappeared and only occasionally surfaces to the delight of her admirers. The listing which follows is incomplete and additions will continue to

be made as new "finds" are reported. The period where her art prints were used to make premiums for the Hawkeye Pearl Button Company of Muscatine, Iowa, and the Glendale Knitting Corporation (The Perry Knitting Company of Perry, New York) is also included here.

The Osborne Calendar Company:
 "Adam and Eve" (1905) assigned #46, #1496, and #2446

Woman's Home Companion Magazine:
 "Bubbles," The *WHC* 1908 Baby Calendar

Swift & Company of Chicago:
 "Swift's Premium Nature Study Calendar for 1915" (four panels)

Brown & Bigelow Company (St. Paul, Minnesota):
 "The Defenders" #120
 "Allow Me" #121
 "A Little Breezy" #122
 "Which Hand?" #123
 "New Arrivals" #124
 "Easter Boy" #125
 "First Aid" #126
 "Vacation" #127
 "The Runaways" #128 also #MY6143 (large format)
 "His First Attempt" #129
 "Who's Afraid" #130
 "Tired Out" #131 also #MY6149 (large format)

The Hawkeye Pearl Button Company and Glendale Knitting Corp. (14″ × 21″):
 1928 "Awakening" #664
 1930 "Contentment" #781
 1932 "In Slumberland" #786
 1936 "In Disgrace" #792
 1939 "Going To Town" #797
 1940 "The Reward" #794
 1941 "Little Mother" #803
 1946 "Mine" #798
 1947 "Who's Sleepy?" #816
 1948 "His Majesty" #793
 1950 "Television" #821
 1951 "A Little Bit Independent" #823
 1952 "My Baby" #824
 1953 "Popularity Has Its Disadvantages" #825
 1954 "A Star From The Sky" #817
 1955 "In Disgrace" #792
 1956 "Nitey-Nite" #826

The Robert Chapman Company (New York):
 1912 "Crowning the May Queen"

POSTCARDS

Since no production records were maintained by Gutmann & Gutmann of their postcard activities, it is impossible to be totally accurate. Approximately seventy different postcards have been identified to date and it is assumed that all of these cards

were issued between 1909 and 1913. Phantom cards of Bessie Pease Gutmann pictures have appeared in foreign languages that were never seen in the United States as postcards—"In Disgrace" has appeared in French and "A Little Bit of Heaven" in German. The first postcards were printed in Germany for Gutmann & Gutmann, but the high import tariff of the Payne-Aldrich Act of 1909 put a stop to the European production and the postcards were soon printed and distributed by Reinthal and Newman of New York. Postcards were, however, printed for Gutmann & Gutmann by publishers and distributors: Chas. H. Hauff (London), Leo Stainer (Innsbruck), Entered Stationers Hall (London), The Alphalsa Company, Ltd. (London), Samuel Prince (New York), A.R.&C.I.B. (Germany), Emil Pinku (Germany), and a publishing firm in Petrograde, Russia.

The postcards were produced with a series in mind and numbered accordingly, however, they were never given titles. Assigned titles by the author with company-issued numbers are:

Fancy Women	#500–505
Young Girls	#800–805
Babies Sitting	#900–904
Mothers with Babies	#1000–1004
Young Women	#1100–1104
The Five Senses	#1200–1204
Events in a Woman's Life	#1300–1304

The following list of postcards is alphabetically arranged with the assigned publisher's number shown (when available):

"Alice" #803
"All is Vanity" #902
"Autumn"
"Baby Mine" #1003
"The Baby" #1300
"Baby's First Christmas"
"Betty" (also with poem) #801
"Blue Bell"
"The Bride" #1303
"The Captive" #700
"The Capture" #1299
"Come Play With Me" #901
"Contentment" #900
"C.Q.D."
"Cupid's Reflection" (three versions known)
"Daydreams" #503
"The Debutante" #1302
"Delighted"
"Dessert" #904
"Dorothy" #805
"Fall"
"Falling Out"
"Feeling"
"The First Born"
"The First Lesson"
"The Foster Mother" #704
"Girl in Hat"
"Happy Dreams" #1104
"The Happy Family"

"Hearing" #1203
"His Majesty" #903
"I Love to be Loved by a Baby" #1001
"In Slumberland" #1002
"I Wish You Were Here" #505
"The Lone Fisherman" #201
"Love at First Sight"
"Love is Blind"
"Love or Money?"
"Lucille" #804
"Making Up"
"Margaret" #800
"The Mother" #1304
Mother looking at baby in a bassinet (untitled card)
"Music has Charms"
"The New Love" #200
"Off to School" #1301
"My Bruzzer had a fever. . ." (poem card)
"Poppies" #504
"Rag Time"
"Repartee" #1100
"Rosebuds" #500
"Seeing" #1201
"Senorita" #501
"Skater"
"Smelling" #1202
"Speeding" #1103
"Spring"
"Stolen Sweets" (unsigned)
"Strenuous"
"Summer"
"Sunshine" #1000
"The Sweetest Joy" #1004
"Sweetheart"
"Sweet Sixteen" #1102
"Tasting" #1200
"Verdict: Love for Life"
"Virginia" #802
"Waiting" #502

PUBLISHED ART PRINTS

For almost five decades (1902–1952) Bessie Pease Gutmann created works for the fine art trade. Nearly 400 separate pieces have, so far, been identified as being reproduced as fine art prints. Although the Gutmann & Gutmann Company did none of its own printing and jobbed the work to several New York printing and engraving firms (such as Quadri-Color, Inc., Manhattan Photo, Manhattan Photo Gravure, L. Winkler Company, and Walker Engraving Company) a strict regimen of quality control was maintained. This did not, however, pertain to the record-keeping system since new "discoveries" of Bessie Pease Gutmann works are constantly being reported. Publishing numbers were changed resulting in different prints having the same number, or in several instances, no numbers at all. Gaps which appear in the

sequential numbering of prints since 1904 reveal that close to 200 numbers have no prints ascribed to them or were never assigned to a print.

No official records were used to develop the listing shown in this section. Research conducted in the United States Copyright Office in Washington supplied the basic information but, unfortunately, this information was incomplete, resulting in many errors in the initial and subsequent listings. Verifications were made through on-site inspection of private collections; the Life Publishing Company Catalog; the Cosmopolitan Print Department Catalog of 1919; The Butler Bros. catalog of 1916 which featured framed prints produced by The Ohio Art Company of Bryan, Ohio; R. H. Macy & Co. of New York 1908 catalog, pgs. 218–219; and the seven catalogs published by the Gutmann & Gutmann Company from July 4, 1906 to June, 1929. Corrections, deletions, and additions are expected to continue with any published listing.

This is a listing, ordered chronologically, in accordance with the year of copyright. The year of copyright is usually commensurate with the year of marketing, however, it does not necessarily correspond with the year that the original work was done. Many examples of several years of lasped time between the original work and the marketing of same have been identified. Unless otherwise noted, all prints shown were originally copyrighted by Gutmann & Gutmann.

1904 "Under the Mistletoe" (Dodge Publishing Co.)
 "The First Valentine" (Dodge Publishing Co.)

1905 "Adam and Eve" (Osborne Co.)
 "Christmas" (Dodge Publishing Co.)
 "Happy New Year"
 "Life and Death"
 "Lips That are For Others (also "Making Up") #100
 "Little Voyagers" #103
 "Man's Ambition"
 "Not His Match"
 "Queen of Hearts"
 "A Slippery Situation" (also "Go 'Way")
 "Springtime"
 "Summer"
 "The Sunshine of the Home" (Dodge Publishing Co.)
 "Surprised"
 "Tile We Meet Again"
 "Twixt Smile and a Tear" (also "Falling Out")
 "W-A-Y Up" #105
 "Young America 1"
 "Young America 2"
 "Young America 3"
 "Young America 4"

1906 "The Baby of the Lake"
 "Butterflies and Daisies"
 "Dawn of History"
 "Gee Whiz!"
 "Her Sole Support"
 "How Miss Tabitha Cat Taught School" (Dodge Publishing Co.)
 "Light of the Orient"
 "Little Black Blew"
 "A Little Pearl" (also "Mermaid Pearls")

"Pearl"
"Please Go Away and Let Me Sleep"
"Studying Art" (also "Impressionists")

1907 "De-lighted" (also "The Happy Hunter") #201
 "Drawing from the Model"
 "Falling Out" (also "Twixt Smile and a Tear")
 " Go'Way" (Also "A Slippery Situation") #104
 "The Happy Family" (also "Who Says Race Suicide") #301
 "The Intruder" #204
 "Little Voyagers"
 "Love is Blind" #109, #202
 "Love or Money?" #106
 "Making Up" (also "Lips That are For Others") #100
 "Mischief" #122
 "The New Love" #107, #300, #673
 "The New Love" (with wallpaper background)
 "Not His Match" #102
 "The Old Love"
 "One Touch of Nature Makes the Whole World Kin"
 "Rag Time" #200
 "The Reckless Rider" (also "The Strenuous Life")
 "The Strenuous Life" (also "The Reckless Rider")
 "W-A-Y Up"
 "Who Says Race Suicide" (also "The Happy Family")

1908 "Asleep"
 "Exceeding the Speed Limit" #210
 "The Little Mother" #206
 "A Lullaby" #205
 "Not Such Geese"
 "The Poodle Mobile" #209
 "School Days"
 "Wild Geese" #207

1909 "Brother Had a Fever" (also "The Water Cure") #212
 "Buds" #603
 "Bye-Bye" #116
 "Cupid's Reflection" #602
 "Feeling" #19
 "Feeling" #118
 "The First Lesson" #111
 "Girl with Lily"
 "Hearing" #22
 "Hearing" #119
 "Hearing" #209
 "His First Attempt" #219
 "I Love to be Loved by a Baby" #159, #607
 "Pies that Mother Used to Make" #401
 "Preparing for the Seashore" (Robert Chapman Co. #1189)
 "Seeing" #20
 "Seeing" #117, #122
 "Seeing" #211
 "Serving Thanksgiving Dinner" (Robert Chapman Co. #1192)
 "Smelling" #18

"Smelling" #120
"Spring" #304
"Summer" #305
"Sweet Sixteen" #154, #601
"Tasting" #21
"Tasting" #121
"The Verdict: Love for Life" #113
"The Victor" #114
"The Water Cure" (also "Brother Had a Fever") #212
"The Winged Hours" (also "Swing Girl" (#219)
"Winter" #307

1910 "The Anxious Mother" #214
"Baby's First Christmas" #605, #158
"A Brown Study" #611
"A Call to Arms" #806
"Crowning the May Queen" (Robert Chapman Co. #1190)
"Cupid 'After All My Trouble' " #608
"Easter Boy" (also "The Easter Gift") #125
"Easter Girl" #217
"Fall" #306
"He Won't Bite" #208
"The Lone Fisherman" #201
"March Hare" #124
"Merely a Man" #218
"Music has Charms" #207
"My Darling" #610
"Sweetheart" #600
"Swing Girl" (also "The Winged Hours") #219
"The Tie that Binds" #606
"Two Heads with but a Single Thought"
"The Vanquished" #115

1911 "After All My Trouble" #608
"The American Girl" #220
"Autumn" #306
"Blue Bell"
"Brown Eyes"
"Busy Day in Dollville" (The Wells and Richardson Co.)
"Buttercup"
"The Christmas Wreath"
"Cupid, That's Me" #249
"Daisies" #216
"Excuse My Back"
"The Foster Mother" #704
"Girl in Coat"
"Girl in Hat"
"Good Morning" #311, #671
"Good Night" #613
"Her Legacy" #609
"His Queen" #215
"I'm Ready"
"The Kiss #612
"The May Queen" #309
"One Day a Nickel Met a Dime"

"Please Have Some"
"A Red Rose"
"Rosebud"
"Senorita"
"Spring"
"Spring Maid"
"Sue"
"The Sweetest Joy" #157, #614
"To Love and To Cherish" #615
"Winter"

1912 "Baby in Bassinette" #617
 "Baby Mine" #616
 "Baby's First Birthday" #618
 "Bud of Love" #619
 "The Butterfly" #234, #632
 "By Candlelight" #148
 "Caught Napping" #153
 "C.Q.D." #149
 "Cupid Will Get You If You Don't Watch Out" #131
 "Mischief Brewing" #152
 "Now I Lay Me" #620
 "Repartee" #147
 "To Have and To Hold" #625

1913 "The Baby" #627
 "The Bride" #629
 "Come Play with Me" #901
 "The Debutante" #630
 "Dessert" #904
 "His Majesty" #162
 "Madonna" #674, #912
 "Mine" #624
 "The Mother" #628
 "Off for School" #631
 "Our Alarm Clock" (no quilt) #150
 "Our Alarm Clock" (with quilt) #224, #626

1914 "Blossoms" #635
 "Bunny" #170
 "Day Dreams" #634
 "Defeated" #404
 "Dreams Come True" #636
 "Is He There?" #405
 "Light of Life" #633
 "Nature Studies, Animals" (Swift & Company)
 "Nature Studies, Birds" (Swift & Company)
 "Nature Studies, Butterflies" (Swift & Company)
 "Nature Studies, Flowers" (Swift & Company)
 "Peek-A-Book" #403
 "Rollo" #171
 "Rover" #173
 "Shelton"
 "Speeding" #637
 "Spring Bells" #401

"A Sunbeam in a Dark Corner" #638
"Tabby" #172, #761

1915 "Daddy's Coming" #644, #223
"Dimples" #179
"A Double Blessing" #232, #643
"God Bless Papa and Mamma" #178
"Happy Dreams" #801
"Lorelei" #645
"Mermaid Pearls (also "A Little Pearl)
"The Message of the Roses" #641
"Mighty like a Rose" #222, #642
"My Dolly" #400
"Preparedness"
"Poverty and Riches" #640
"Smile Worth While" #180
"Stepping Stones"
"Sweet Innocence" #208

1916 "Baby Arms"
"Girl in Green"
"The Guest's Candle" #651
"Introducing Baby" #646
"A Little Bit of Heaven" #650
"The New Home" #217
"Peach Blossoms" #649
"Poinsettia Girl"
"Spring Maid"
"Yes or No?" #212

1917 "Blossom Time" #654
"Home Builders" #233, #655
"Knit Two, Purl Two" #657
"Love's Message" #652
"Mother's Kiss"
"The Wedding March" #653

1918 "Angels' Kin" (also "Awakening") #259, #664
"Blue Bird" #265, #666
"The Builder"
"Chums" #263, #665
"The Fairest of the Flowers" #659
"Feathered Friends"
"Grandmother's Wedding Dress" #660
"Happy Days" #352, #669
"Harmony"
"Mothering Heart" #351
"Once Upon a Time" # 658
"Pack Up Your Troubles in Your Old Kit Bag and Smile, Smile,
 Smile" (also "Smile, Smile, Smile") #225, #662
"Rose in Bloom" #350
"Sunny Corner"

1919 "The Great Love" #678
"The Newcomer" #262, #685
"Watchful Waiting" #679
"When Daddy Comes Marching Home" #668

1920 (No production)

1921 "The Aeroplane" #266, #694
"Goldilocks" #771
"Heart's Ease" #699
"In Arcady" #269, #701
"On Dreamland's Border" #692
"Symphony" #270, #702
"The Winged Aureole" #267, #700
"Wood Magic" #268, #703

1922 "Annunciation" #705
"An Anxious Moment" #711
"Mother Arms" #413
"The New Pet" #709

1923 "All Mine" #717"
"The Bedtime Story" #712
"Bubbles" #714
"Chip of the Old Block" #728
"The Divine Fire" #722
"The First Dancing Lesson" #713
"Reflected Happiness" #716

1924 "Mischief" #729
"On the Threshold" #731
"Sunbeam" #730

1925 "A Priceless Necklace" #744
"Twins" #745

1926 "Always" #774
"Fairy Gold" 770
"Love is Blind"
"My Honey" #756
"Rosebud" #780
"Snow Boy"

1927 "Snowbird" #777
"Springtime" #775

1928 "Buddies" #779
"Light of Life"
"Sunny Sonny" #778

1929 "Busy Day" #782
"Contentment" #781
"Good-bye" #783
"Sonny Boy" #784

1930 "Sunshine"

1931 "Betty" #787
"Billy" #790
"Bobby" #789
"In Slumberland" #786
"Love's Blossom" #785
"Tommy" #788

1932 (No production)

1933 "Goldilocks" #201
 "Little Boy Blue" #206
 "Little Bo-Peep" #200
 "Little Jack Horner" #205
 "Little Miss Muffet" #204
 "Pals" #207
 "Sister" #203
 "Sunshine" #202

1934 "Feeling" (also "Touching") #210
 "Hearing" #209
 "Seeing" #211
 "Smelling" #213
 "Sweet Innocence" #808

1935 "In Disgrace" #792
 "Love's Harmony" #791
 "Tasting" #212

1936 "His Majesty" (blue or pink blanket) #793
 "The Reward" #794

1937 "Chuckles" #216, #799
 "Friendly Enemies" #215
 "In Port of Dreams" #214
 "Love is Blind" #795
 "Miss Flirt" #217

1938 "Going to Town" #797

1939 "Happy Dreams" #800

1940 "Good Morning" #801
 "Harmony" #802
 "Little Mother" #803

1941 "Kitty's Breakfast" #805
 "Sympathy" #804

1942 "Good Night" #807
 "In Trouble" #222
 "Jack be Nimble" #218
 "Sweet Dreams" #220, #810
 "Tom, Tom the Piper's Son" #219

1943 "May We Come In" #808
 "Perfect Peace" #809

1944 (No production)

1945 "Oh! Oh! A Bunny" #811
 "Two Sleepy-Heads" #812

1946 "The First Step" #815
 "Just a Little Bit Independent" (with nightgown) #814
 "Taps" #813
 "Who's Sleepy" #816

1947 (No production)

1948 "A Star from the Sky" #817
 "Sunkissed" #818

1949　"Asking for Trouble" #820
　　　　"The Lullaby" #819
　　　　"Television" #821

1950　(No production)

1951　"Just a Little Bit Independent" (with pajamas) #823
　　　　"Thank You God" #822

1952　"My Baby" #824
　　　　"Nitey-Nite" #826
　　　　"Popularity has its Disadvantages" #825

MISCELLANEOUS WORKS

This listing represents all those items which featured the artwork of Bessie Pease Gutmann and was presented to the public in some form. In several instances the origin of the item cannot be traced and may have been a clandestine piece never authorized by the Gutmann & Gutmann Company for production.

Jigsaw Puzzle

"Baby's First Christmas," a print issued by Gutmann & Gutmann in 1910, was produced by the Young America Picture Puzzle Company as a 9″ × 12″ jigsaw puzzle. The origin of this item is not known nor is there any mailing address of the company noted. It is at least seventy years old judging from the quality of paper used.

Paper Fan

The Brown & Bigelow Company manufactured a paper fan in 1909 featuring an illustration by Bessie Pease Gutmann ("The Runaways") and assigned it a company number of F6143. This full color, 8″ × 10″ paper fan contained advertising on the reverse side.

Baby Rattle

A celluloid rattle with the image of "Awakening" featured was discovered at a flea market in Rockford, Illinois in 1985. The rattle is evidently a pre-World War II import from Japan. Three such rattles have been reported in the past four years.

Advertising Postcards

Many enterprising merchants purchased quantities of the regular issues of postcards featuring Bessie Pease Gutmann art and imprinted sales messages that were sent to prospects. The cost of the card and the one cent postage stamp was considered inexpensive advertising. Cards which have been seen are:

> "Virginia" #802. Message: "Advertise to the child and you'll reach the parents"
> "Strenuous" #203. Message: "At the sign of the arrow to be well-dressed . . .
> 　buy your next suit and overcoat from . . ."

The Ladies Home Journal

Bessie Pease Gutmann illustrated clothing patterns for a regular feature known as "Mrs. Ralston's Clothing Patterns" from 1906–1907.

Christmas Cards

- #1 Child with curly hair, pink ribbons, sucking on candy cane.
- #2 Head of beaming dark-haired child with white winter outfit against background of leaves.
- #3 Young dark-haired child dressed in white cap, coat, mittens, and leggings, carrying doll with blonde hair in one hand and a package tied with a red ribbon in the other.
- #4 Sketch of Madonna with Child
- #5 Blonde-haired baby with white winter hat in a wreath of holly, almost a profile.
- #6 Full-face blonde-haired baby with white winter hat in a holly wreath.
- #7 Child with long blonde hair looking at a doll she is holding, set in a round floral border with ribbon.
- #8 Profile of young child, blonde, bobbed-hair, middie blouse, holding a puppy.
- #9 Profile of blonde-haired choir boy carrying a lighted candle.
- #10 Little girl with long blonde curls, bow in hair, holding an oriental doll.
- #11 Full-faced baby with light brown curly hair, floral pattern framing the background.
- #12 Baby with white winter cap and sweater tied with pom pom tassels, mistletoe framing head in background.
- #13 Portrait of blonde curly-haired child (similar to "Sunbeam" #730).
- #14 Portrait of a young girl (Alice, daughter of Bessie Pease Gutmann) with dark hair, wearing a winter cloche hat with a feather in it.
- #15 Blonde curly-headed baby asleep facing left, in a circle on front panel (sprig of mistletoe hangs over the bottom of circle). Card opens from the top (only standard message on inside), hand tinted.
- #16 Panel card of laid paper, young curly-haired child asleep holding doll to the right.
- #17 Winter rooftop scene, stork in foreground and cathedral in background. Single panel, split image with legend on bottom fourth in a sprig of holly. Message: "Greetings from the Gutmans [sic]."
- #18 Single panel card of baby sitting on top of world with snowflakes falling around him (no message—may have been a New Year's card).
- #19 Curly-headed child in double circle (similar to "Mischief" #729).
- #20 Full-face baby with white winter hat and small curl on forehead, in a single line circle, encircled with holly leaves and berries.
- #21 Madonna and Child (similar to "Light of Life" #633).
- #22 Two young children playing in a snow fort.
- #23 Blonde curly-headed child asleep with Christmas toys around him in his crib.

MAGAZINE ILLUSTRATIONS— POETRY AND ARTICLES

The following list gathers together Bessie Pease Gutmann's illustrations which appeared in numerous publications, either singly or as part of an illustrated article or story. The list of publications is arranged alphabetically with illustrations chronologically ordered under each title.

Pearson's Magazine

October 1905. "The Lost Children of Greater New York" by Robert Sloss
Illustration (no title)

"A very forlorn little object"
"In a station house waiting to be reclaimed by their parents"
"Lost children making a play of their own station house experiences"

December 1905. *"Cupid and the First Reader, a Story"* by Amanda Mathews
"Apparently she could scarcely desist from building letter-cards into words long enough to open it"
"Ramon peering eagerly into car after car"
"I no can study when Greasers all the time hug themselves"

February 1906. *"The Foundlings of New York City"* by Annette Austin
"A professional nurse weighs them at stated intervals"
"Caught the fleeting smile of another baby"
"The babies were brought out at all times, for all purposes, and presented"

April 1906. "The Fairies and the Babies" by W. H. G. Wyndham Martyn
May 1906. "The Triumph of the Twins" by W. H. G. Wyndham Martyn
"Get your sword ready, to rescue me at once if the dragon comes"
"They finished the milk between them"

September 1906. "When the Toys Wake Up" by W. H. G. Wyndham Martyn
December 1906. "At the Sheepfold" by Edgar Benet. Three illustrations listed.
January 1907. "Treat Day" by Zona Gale
Illustration (no title)
"Leda Morn was one of the spring morning women who preserve the May and teach its ways to the rest of the year"
"Leda Morn came toward us, children laughing about her, her face lighted with their happiness"

Saint Nicholas Magazine

October 1904. "Smiling, Slip Asleep" by Alex Jeffrey
August 1905. "On the Hillside" by F. S. Gardiner
December 1905. "Brave Annabel Lou" by Clara Odell Lyon

Woman's Home Companion

December 1907. "Cap'n Gilly" by Mary Catherine Lee
"Investigation revealed a boy concealing himself—a boy of seven, who was ashamed to be seen weeping"
"A little unskilled laborer struggling to offset the powers of the air"
"Directly settled upon a hassock by the fire, with a small tray on a chair before him"
"Passively and unquestioningly he took these attentions"
"He kept his earnest eyes fixed upon the face of his visitor"

PRINT VARIATIONS

In the early days of hand-coloring or hand-tinting, regular firms were in business just to apply color to the single color inkings that came from the printing firms. These coloring firms, or colorists, were employed to apply color, usually watercolors, to the single color prints. Quality control was not as sophisticated as the present day, so coloring "errors" often appeared. Although Hellmuth Gutmann was known as a

demanding business person and one that quite frequently rejected a printer's proof or the work of a coloring firm as being unsatisfactory, he exercised little control once the final production stages began.

The artworks of the first three decades of the 1900s came from the printing firms "finished," that is, in one ink color, usually sepia or brown, dark blue, or black. The dark lines produced by the ink color provided the best base for color application. Gutmann & Gutmann employed a colorist firm to hand-color the prints according to a coloring sample usually supplied by Bessie Pease Gutmann. Often the prints would be in such demand that haste to market them was required and they were marketed in the single color. An agent of the Gutmann & Gutmann firm in Australia, in a letter dated 17 May 1917, clearly calls attention to this by stating, "Bulk pictures must be sent to us uncolored but we will esteem it a great favor if you will mail us, packed separately, one of each picture colored, sending the invoice direct to us. This will give us a correct model for our artists to work from."[72]

Most of the early Gutmann prints were hand-tinted and often the printing firm would make a substantial run of un-colored prints of the same work. When the coloring work was transferred to another firm, it became possible that different colors, or different shades of the same color, caused variations when the same prints were compared. The "sample" artist-prepared color print would be sent back to the printing firm where assembly-line techniques were used to turn a black, sepia, or dark blue line print into a "hand-colored" print. The printing firm might have used a subcontracted colorist firm to do the coloring. The non-colored print would be handed down a line of colorists, each of whom would apply a different tint to a picture. By the time the print reached the end of the line all the colors would be filled in but no single colorist/artist would have worked on an entire print.

Such practices led to many types of oddities turning up on the print market. The collectors of today search for such "differences" as do the philatelists and numismatists with their stamps and coins. Some of the changes in coloring that appear on the prints of the time were intentional. It was quite common to change a color or a title of a print in order to make it more attractive to the buying public. "His Majesty" (1936) featuring a little tyke in a highchair was originally issued with a blue blanket. However, such a clamor arose that the same image was issued with a pink blanket too. Since prints did not distinguish baby boys from baby girls, it was a common practice to issue an artwork with blue or pink colors predominating. This was quite true with the paired prints "A Little Bit of Heaven" (1916) and "Awakening" (1918). Titles were shortened and changed, as well as a Teddy bear, a lamb, or some toy being added to the print. An outfit color change in "The Reckless Rider" became "The Strenuous Life" in 1907.

One of the most interesting variations found concerned the alteration of a title which the artist did not participate in. Sometimes the issued titles would prove to be cumbersome, not understood by the public, and in general were not acceptable and didn't sell. The 1907 print, "Who Says Race Suicide?" which illustrated a typical enchanting little girl, hair in curls with two blue satin bows, all dressed up with her pretty Mary Jane shoes, seated on a sofa with her "family" of twelve dolls of varying sizes and dress, was not acceptable to the buying public. The title was taken from a nationwide debate over the immigration laws which were permitting immigrants of all races (particularly the Asians who were referred to as the "yellow peril") and nationalities to enter the country. There were those who claimed that soon one race would cease to exist and so the debate went on. The print title proved to be a poor one for it was caught up in the debate, so the firm quickly reissued the print under the new title, "The Happy Family," and a few years later issued a postcard under the same title.

Several of the works by the artist were issued as prints under one title then reissued with slight variations in order to fulfill a commercial commitment or to simply make a

print more marketable. When a contract with a children's nightwear company was received, Gutmann & Gutmann reissued the 1946 print, "Just A Little Bit Independent," illustrating a young girl in a nightgown. This time (1951) it featured the same young lady wearing pajamas. A similar situation occurred in 1952. The firm, under contract to another sleepwear company, took the 1938 print "On the Up and Up," which showed a little boy dressed in rompers climbing a flight of stairs with his spotted puppy dog, and re-dressed the little fellow in pajamas and reissued the print under the new title, "Nitey-Nite" (1952). Also reported has been "Our Alarm Clock" (1913) found without a quilt and "The New Love" (1907) with a wallpaper background.

Other examples of title changes are: "Angels' Kin" to "Awakening" (1918), "The Water Cure" to "Brother Had a Fever" (1909), "The Happy Hunter" to "Delighted" (1907), "A Slippery Situation" to "Go Way" (1907), "Lips that are for Others" to "Making Up" (1907), "Mermaid Pearls" to "Little Pearl" (1918), "Pack Up Your Troubles in Your Old Kit Bag and Smile, Smile, Smile" to "Smile, Smile, Smile" (1918), "The Reckless Rider" to "The Strenuous Life" and then "Strenuous" (1907), "The Winged Hours" to "Swing Girl" (1910), and "Twixt Smile and a Tear" to "Falling Out" (1907).

SIGNATURES

Collectors soon become aware that Bessie Pease Gutmann art could be identified by the type of signature she used. Her work went through a series of changes beginning with her first use of the "balloon" type signature prominent among artists of the time, including Alice Barber Stephens, Charlotte Harding Brown, and Jessie Willcox Smith. She also used her initials "B.C.P." in the balloon style, and B.P.G. later on. Confusion sometimes exists with the signatures, "Gutmann" or "B. Gutmann," for this was the manner in which her brother-in-law Bernhard Gutmann signed his early illustrative work.

Prior to her marriage, most of her early signatures were of the balloon-type and then shortly after her marriage in 1906 her "squared-signature" appeared. Most of her work carried this form until she adopted the script-like signature with the elongated "G" which served to identify her work until she stopped working for publication.

In the later years she chose to sign her work with signatures for which no explanation has been given. Two such "mystery signatures" appeared on "Sweet Sixteen" (1909), where she signed her name through a birthday cake, and "Sweetheart" (1910), where her signature runs through a double heart.

IT WASN'T ALL ROSES. . .

Bessie Pease Gutmann, like so many other artists, had her own problems with some technical feature of her art skills. Her early sketch pads show innumerable drawings of hands and fingers in a variety of positions. At the outset of her formal training she experienced difficulty with the recording of the extremities in natural and unaffected poses. Page after page of hundreds of tiny sketches of hands, arms, and fingers contained in her sketchbooks indicate that she was always practicing the transference of her sketches to the finished works on illustration board or canvas.

Although a skilled artist who worked with comparative ease, she was not free of moments of frustration. One such moment occurred while working on an oil on

canvas study of her oldest daughter Alice. She kept trying and trying to interpretively transfer the hands of the model to her canvas, but never to her satisfaction. Finally, in a brief moment of frustration, she took a rag and smeared the hand in an attempt to wipe it out. This beautiful portrait study remains unfinished, however the image did find its way onto one of the Christmas cards the Gutmann family sent to friends. The image on the Christmas card (#14) showed only the head and shoulders of Alice . . . and no hands.

WHERE HAVE ALL THE ORIGINALS GONE?

In 1989 the Mid-Hudson Galleries of Cornwall-on-Hudson, New York, auctioned the largest single lot of Bessie Gutmann art prints to date. A total number of twenty-eight lots were sold and new sales records were established. The following was recorded: "Always" No. 774, $950.00; "Buddies" No. 799, $525.00; "The Great Love" No. 678, $325.00; "Home Builders" No. 665, $300.00; "The Message of the Roses" No. 641, $300.00; "A Double Blessing" No. 643, $225.00; "In Disgrace" No. 792, $250.00; and a matching pair of "Mischief" No. 729 and "Sunbeam" No. 730 brought $450.00. Prices such as these for prints raised the question of what the value of originals would be. But what of the original artwork? No recorded sale of original work done by Bessie Pease Gutmann had been made to date. A mid-west party did offer the original paintings of "In Disgrace," "Kitty's Breakfast," and "The Reward," at $5,300.00 each but no sales have been reported.

Certainly much of the original art must have withstood the aging process. The absence of her original works in galleries and auctions causes considerable speculation. Perhaps there are fewer examples of her original work than one would imagine and this possibility must be considered when we realize how the early, pre-1935, prints were produced.

Working primarily on consignment, Bessie Pease Gutmann would complete a work of art generally in charcoal, pencil, India ink wash, or Conte crayon, and this piece would be sent to the photogravure firm that was handling the printing for Gutmann & Gutmann at the time. At the printing plant a plate (copper or zinc) would be prepared and a single copy run on a proofing press and returned to the firm. After a meticulous examination it would be returned to the printer either approved or corrections offered. The printer would prepare his presses for a quantity run and would send his first run (called "printer's proofs") copies to the artist who would then, using watercolorings, establish the coloration formula to be used. There was no longer any further need for the original artwork and it was no longer considered important, so the printer either filed or destroyed the work, unless the artist specifically requested it to be returned. The absence of much of the original black and white artwork would seem to indicate that the artist did not request the return of a considerable number of her works. It must be concluded, therefore, that the original artwork created for reproduction rarely outlived the brief exposure to the copy camera or the plate-makers work. With the advent of lithography and the improvements to the color printing process, few art prints were hand-colored after 1935.

Many of the original works that were in the possession of family members were given as gifts over the years and, since they were given with love and not with value in mind, they probably remain cherished possessions of the receiver. Will original artwork by Bessie Pease Gutmann be seen by the buying public in years to come? Perhaps, though probably not at auctions or through private sales, but as part of a permanent exhibit in some public institution so all the world may enjoy her art. This would indeed memorialize this great American artist who has brought so much joy to so many.

Bibliography

Articles

"A Woman's Work is Never Done!" *Collector's Showcase Hotline 1* (1985): p. 3.

Armstrong, Regina. "Representative Women Illustrators: The Child Interpreters." *The Critic*, May 1900, p. 417.

Brown, James S. "Still Life Artist Peta Led Parade to Retreat." *Asbury Park Press*, 8 February 1981.

Chase, Doll. "Collectibles in a Candy Store." *Antiques & Collectibles* (1981).

Christie, Victor J. W. "Children's Artist: Bessie Pease Gutmann." *Barr's Postcard News*, 21 March 1988, p. 1.

Flaxman, Annick Story. "The Grande Dames of Children's Art." *Plate World*, July–August 1987, pp. 68–71.

Gutmann, Bessie Pease. "The American Girl." *The Delineator* 72 (1908): 245.

Lancelot, Francis A. "A Painter of Childhood: The Work of Mrs. B. Pease Gutman." *The Girl's Realm* 11 (1908): pp. 129–139.

Leach, Carol. "She Has 100 Kids, Everyone Perfect." *New Jersey Courier-Post*, 21 July 1988, p. 1.

Levitch, Marcy. "In Search Of . . . A Lost Artist." *Essex Journal*, 2 September 1982, p. 3.

"Mount Holly Historical Society Honors Childrens' Artist." *The Mount Holly Gazette*, 25 May 1988, p. 2.

Rodman-Schwartz, Joanne. "Remembering Bessie Pease Gutmann." *Burlington County Times*, 18 November 1988, p. 13.

Rutledge, Mary Jane. "Babies for Models Abound, Explains Painter of 'A Little Bit of Heaven.' " *Newark Sunday Call*, 30 September 1934.

Stephens, Alice Barber. "The Art of Illustrating." *Woman's Progress*, November 1893, p 49.

"The 'Bubbles' Cover." *Pictorial Review*, August 1907, p. 4.

"What Publishers Say About Their Most Popular Picture." *Picture & Gift Journal*, May 1927.

Books

Brown, Ann Barton. *Charlotte Harding: An Illustrator in Philadelphia*. Brandywine River Museum: Chadds Ford, Pennsylvania, 1982.

———. *Alice Barber Stephens: A Pioneer Woman Illustrator*. Brandywine River Museum: Chadds Ford, Pennsylvania, 1984.

Christie, Victor J. W. *Bessie Pease Gutmann Published Works Catalog.* Third Ed. Park Avenue Publishers: Ocean, New Jersey, 1986.

Homer, William Innes. *Robert Henri and His Circle.* Cornell University Press: Ithaca, New York, 1969.

Huber, Christine Jones. *The Pennsylvania Academy and Its Women.* Pennsylvania Academy of the Fine Arts: Philadelphia, 1973.

Knauff, Theodore. C. *An Experiment in Training for the Useful and the Beautiful: A History.* Philadelphia School of Design for Women, 1922.

Mitchell, Gene. *The Subject was Children: The Art of Jessie Willcox Smith.* E. P. Dutton: New York, 1979.

Pitz, Henry C. *200 Years of American Illustrations.* Random House, Inc.: New York, 1977.

Prince, Pamela. *Sweet Dreams: The Art of Bessie Pease Gutmann.* Harmony Books: New York: 1985.

Reed, Walt. *Great American Illustrators.* Abbeville Press: New York, 1979.

Reed, Walt; Reed, Roger. *The Illustrator in America 1880–1980: A Century of Illustration.* The Society of Illustrators: New York, 1984.

Ryan, Dorothy B. *Picture Postcards in the United States 1893–1918.* Updated ed. Clarkson H. Potter, Inc.: New York, 1982.

Schnessel, S. Michael. *Jessie Willcox Smith.* Thomas Y. Crowell: New York, 1976.

Tufts, Eleanor. *Our Hidden Heritage: Five Centuries of Women Artists.* Paddington Press Limited: New York, 1974.

Bulletins

Christie, Victor J. W., ed. *Bessie Pease Gutmann Bulletin* 1–10 (1983–1984).

Christie, Victor J. W., ed. *Official Newsletter of the Gutmann Collectors' Club Inc.* 1 and 2 (1987–1988).

Jones, Susan K., ed. "Bessie Pease Gutmann . . . Internationally Famous American Illustrator and Painter . . . Enters Collector Plate Arena." Collectors' Information Bureau: Grand Rapids, 1986.

Catalogs

Emerson, Edith. *Jessie Willcox Smith, An Appreciation.* Catalog of the Memorial Exhibition of the Work of Jessie Willcox Smith. Academy of the Fine Arts: Philadelphia, Pennsylvania. March 14–April 12, 1936.

1929 Membership List of the Art Centre of the Oranges, East Orange, New Jersey.

7th Annual Exhibition by the Art Centre of the Oranges, East Orange, New Jersey, April 9–24, 1932, p. 3.

Women Artists: In the Howard Pyle Tradition. Brandywine River Museum. Tri-County Conservancy of the Brandywine: Chadds Ford, Pennsylvania, 1975.

Letter

Abigail to John, 31 March 1776. *Familiar Letters of John Adams and His Wife Abigail Adams During the Revolution.* Charles Francis Adams, ed. New York: Hurd and Houghton, 1876.

Subject Index

Works Index